WHITBY

THROUGH THE AGES

Mike Hitches

AMBERLEY

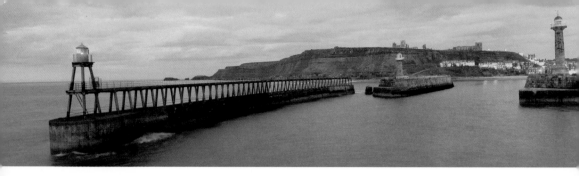

ACKNOWLEDGEMENTS

I should like to offer my thanks to those people who have contributed to making this work possible, in particular John Thurston, who has provided many of the views of Whitby and whose help has been invaluable. I should also like to thank Paul Hughes for his assistance with the story of the railways at Whitby, and for providing some illustrations. Thanks also go to Roger Carpenter, Richard Casserley, Sally and Phil Richardson, and Jayne Girling. Many thanks to Mark Davis for a number of modern shots. Finally, I should like to thank my wife Hilary for her constant support.

First published 2013

Amberley Publishing
The Hill, Stroud, Gloucestershire, GL5 4EP
www.amberley-books.com

Copyright © Mike Hitches, 2013

The right of Mike Hitches to be identified as the
Author of this work has been asserted in accordance with
the Copyrights, Designs and Patents Act 1988.

ISBN 978 1 4456 2171 5 (print)
ISBN 978 1 4456 2186 9 (ebook)

British Library Cataloguing in Publication Data.
A catalogue record for this book is available from the
British Library.

Typesetting by Amberley Publishing.
Printed in Great Britain.

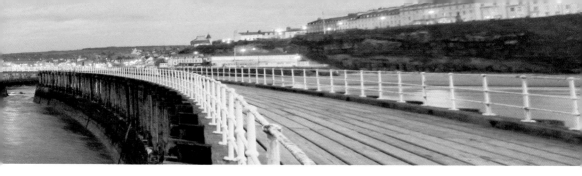

CONTENTS

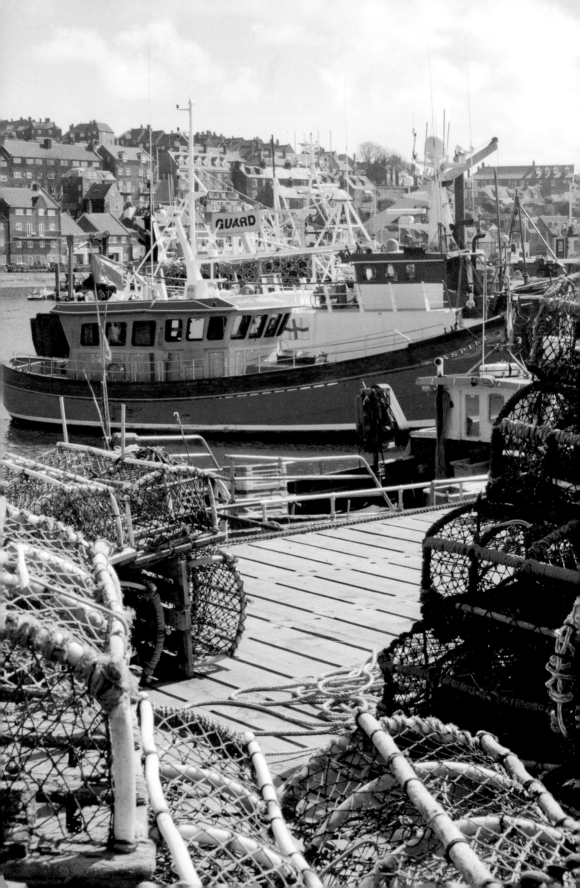

INTRODUCTION

Dominated by the ruins of St Hilda's Abbey, high on the East Cliff, Whitby has a long seafaring history. Indeed, it was the birthplace of the famous nineteenth-century explorer, Captain James Cook, who set sail in his ship HMS *Endeavour* from Whitby to discover Australia and mapped New Zealand on the far side of the world. The town was also famous as a whaling port, along with its fishing industry that continues today. The east and west piers that shelter the harbour are Grade II listed and a swing bridge crosses the River Esk in the town.

Whitby is an old settlement and records show its existence as early as AD 656, when the Christian Northumbrian King Oswy founded the first abbey, run by abbess Hilda; the first synod was held there in 664. Viking raiders destroyed the abbey in 867 but it was refounded in 1078. It was at this time that the settlement became known as 'Whitby' (from the Old Norse for 'white settlement'). Earlier names included Streneshale, Streonshalch, Streoneshath, Streunes-Alae in Lindissi between the sixth and eighth centuries, Prestebi (habitation of priests in Old Norse) in the ninth century, Hwitebi and Witebi in the twelfth century, Whitebi in the thirteenth century, and Qwiteby in the fourteenth century.

Along with fishing and whaling, Whitby developed as a major port as a result of the alum trade, which was mined near Sandsend Ness from the reign of James I, and the importing of coal from the Durham coalfields. Thus, Whitby grew in size and wealth, which allowed the town to extend into shipbuilding using local oak timber. By 1790/91, Whitby had become the third largest shipbuilder in England, after London and Newcastle-upon-Tyne, when it built some 11,754 tons of shipping. The town also benefitted from trade in the transport of coal from Newcastle to London by supplying and building ships for such traffic. Indeed, James Cook started out on collier ships and HMS *Endeavour* was built by Thomas Fishburn at Whitby in 1764 as the coal carrier *Earl of Pembroke*. She was then bought by the Royal Navy in 1768, and was fully refitted and renamed. Development of iron ships in the late nineteenth century and the building of a port on the River Tees, saw the decline of the smaller Yorkshire harbours, including Whitby, which launched its last wooden ship, *The Monks-Haven*, in 1871. A year later, the harbour itself was silted up.

Another industry in Whitby, albeit on a small scale, is the production of jewellery from jet. This black mineraloid is the remains of the monkey-puzzle tree and is found on the moors and in the cliffs around the town. Jet has been used to make beads since the Bronze Age and

the Romans were known to have mined it in the locality. During the Victorian period, jet was brought to Whitby by packhorses and made into decorative items. Whitby jet reached the peak of its popularity after the death of Prince Albert, when Queen Victoria used it as mourning jewellery, fashionable tastes then following the royal lead. After the Queen's death, the popularity of jet decreased, but has found a new market in modern jewellery, especially among 'Goths', who hold festivals twice a year in the town, Whitby having featured in Bram Stoker's Gothic novel *Dracula*.

Despite Whitby's success in maritime industries, businessmen in the town were aware of its isolation on the North Yorkshire coast, with moorland on three sides and the North Sea on the fourth. By May 1831, there were concerns about the decline of these maritime industries and it was felt trade could be enhanced if inland communications could be improved. George Stephenson was asked to survey a railway inland with trains to be pulled by horses. His report suggested a line to Pickering, which could be used to transport coal and other goods inland to market towns in the Vale of Ryedale, with agricultural produce and stone coming the other way for onward shipment by sea. Authority was given for the line in 1833 and it was opened in 1836 – the first railway in North Yorkshire. By 1845, the line was purchased by the York and North Midland Railway (Y&NMR), who extended it from Pickering to the York to Scarborough line at Rillington, giving access to the West Riding and Lancashire. With this extension, the Y&NMR planned to develop Whitby into a major seaside resort to attract well-heeled industrialists.

Whitby had been a spa resort since Georgian times, thanks to the discovery of three chalybeate springs, which were in demand as tonics and medicines. Lodging houses and hotels were built in the West Cliff area, but it was George Hudson, chairman of the Y&NMR, who developed the town for tourism and increased railway passenger numbers. It was he who developed the Royal Crescent, which was only half finished due to his financial situation. Also, on West Cliff, the Royal Hotel was built, along with lodging houses. From these beginnings, Whitby was to become an important railway centre, with a line from Loftus, making a head-on junction with a line from Middlesbrough, opening in 1881, and a line from Scarborough, which joined the line to Loftus at Whitby West Cliff station, opening in 1885. These new railways brought a major influx of holidaymakers into the town until the 1950s and 1960s, which created another source of wealth for the town just as maritime industries began to decline.

Changes in holiday tastes after the post-Second World War 'boom' years brought about a decline in tourism at Whitby, which was not helped by the closure of the railways that served the town. The line to Loftus was closed in 1958, due to the poor state of the iron viaducts on the route, with the line from Scarborough closing in 1965, leaving the anomaly of a railway gap along the coast and Whitby now not being served by a coastal line. The only line now serving the town is the Esk Valley line from Middlesbrough and the only way to travel by main line from Scarborough to Whitby is via York. The North Yorkshire Moors Railway operates an occasional steam service to Whitby, but this is purely for tourism. Thus, the only realistic access to Whitby is by roads over the North Yorkshire Moors National Park, which constrains the local economy due to poor transport infrastructure. The local economy therefore relies on fishing and tourism, which doesn't do much for local employment and income.

THE HARBOUR

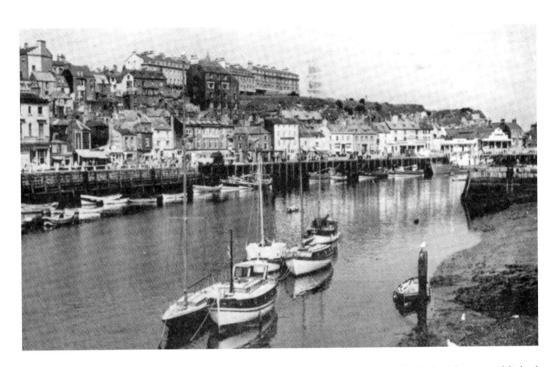

Two views of the harbour at Whitby, with part of the town above. Whitby had been established as a key port in the reign of Elizabeth I and was known for its fishing industry, albeit on a small scale. As a result of developments in the alum and coal trades, Whitby's port grew in size and importance, and was building ships in the eighteenth century, becoming the third largest shipbuilder in England.

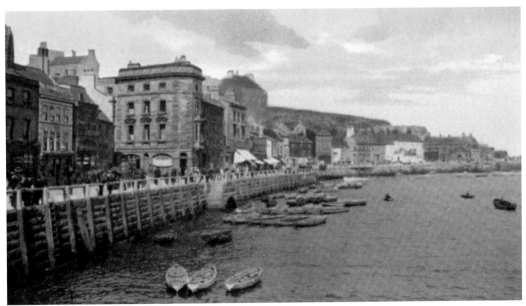

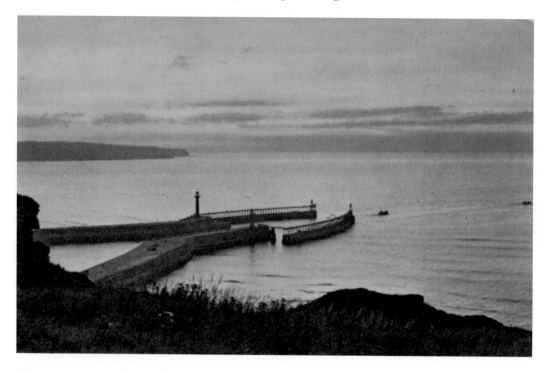

The entrance to Whitby Harbour at dusk with fishing boats moving out to sea.

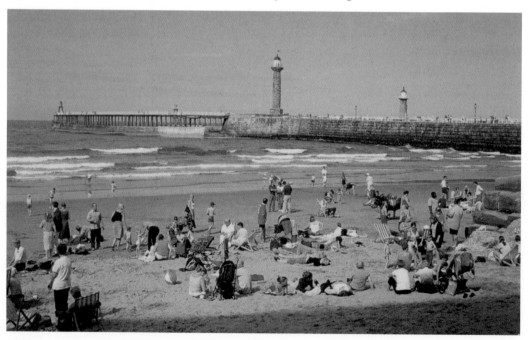

The beach at Whitby during the busy summer season with the harbour wall and lighthouses in the background.

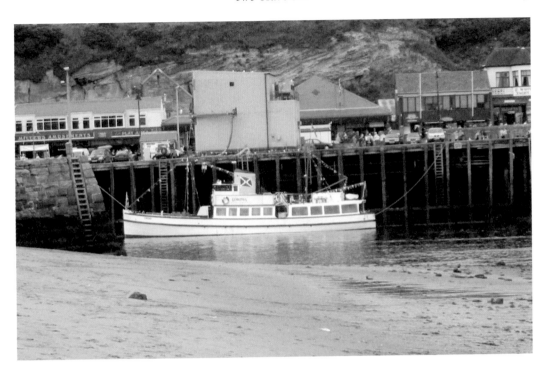

In 1979, a new marina was created by dredging the upper harbour and laying pontoons. Light industry and car parks use the adjacent land. More pontoons were completed in 1991 and 1995, and the Whitby Marina Facilities Centre was opened in June 2010.

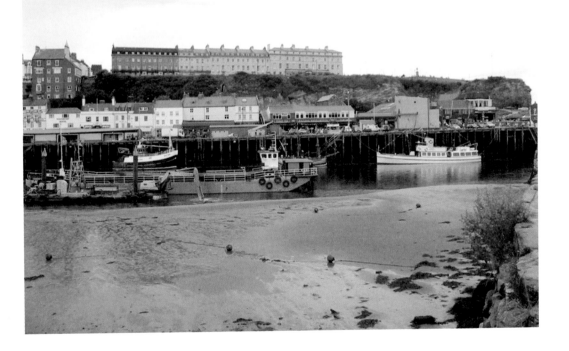

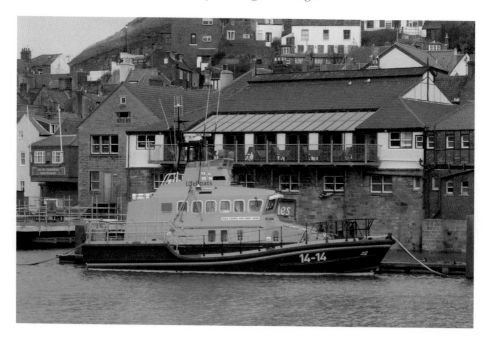

The Whitby lifeboat station was built in 2007 on the east side. The station has two lifeboats, an inshore D Class, the *OEM Stone Ill,* and an all weather Trent Class boat, the *George and Mary Webb* (*seen in the picutre*).

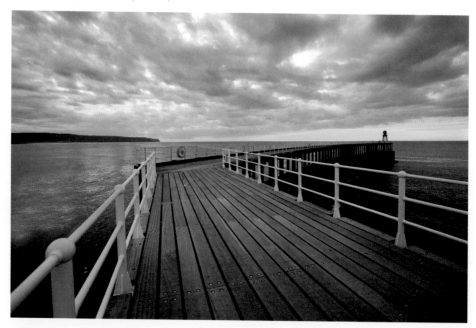

There are two lighthouses, one at the end of each pier, along with a beacon of fixed lights. The west lighthouse, built in 1835, is 84 feet high, while the one on the east pier, built in 1855, is only 54 feet high.

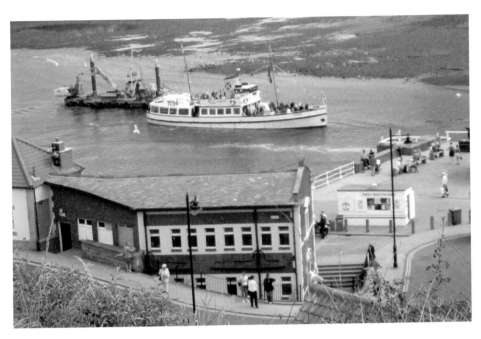

The inner harbour with pleasure boats in view. The harbour is now owned by Scarborough Borough Council after the harbour commissioners relinquished responsibility in 1905 and Endeavour Wharf was opened by the council in 1964, the wharf being close to the railway station. By 1972, the number of vessels using the port was 291, increasing from 64 in 1964. Timber, paper and chemicals are imported through the harbour, while steel, furnace bricks and doors are exported.

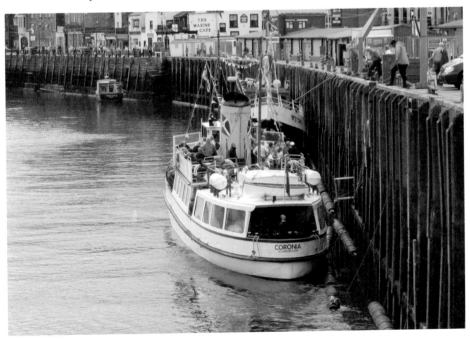

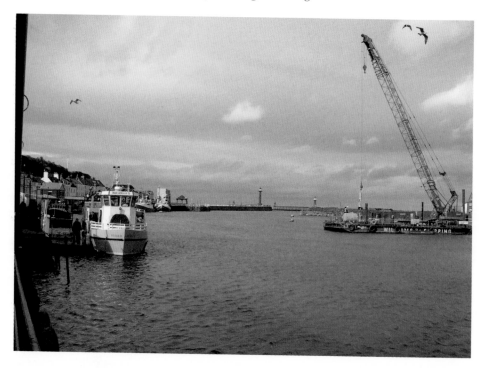

The inner harbour with cranes and the lifeboat in view as a new lifeboat station is being constructed.

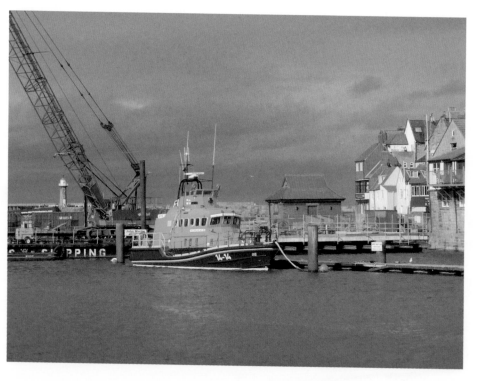

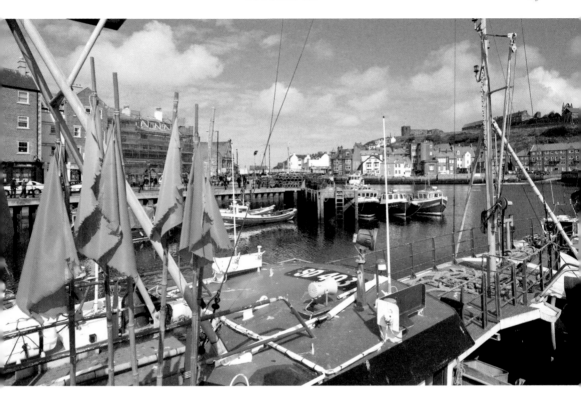

Daytime views of the harbour.

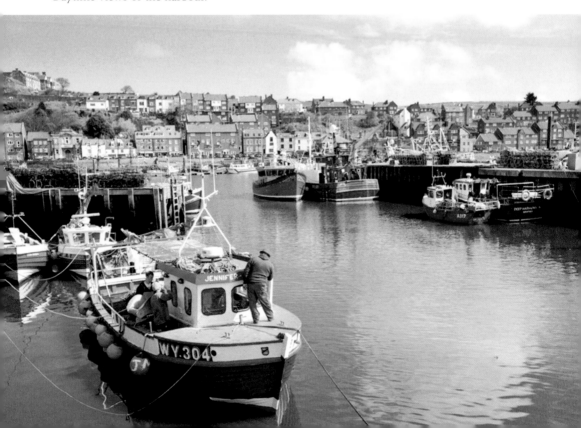

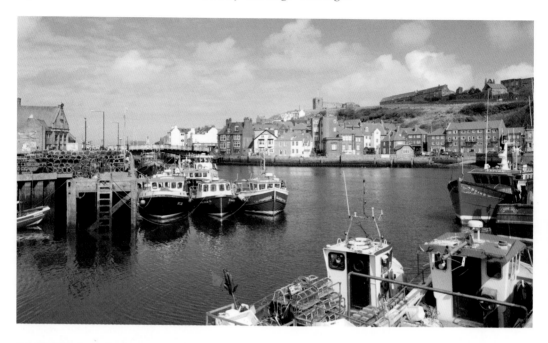

Whitby Harbour, looking towards East Cliff in the upper view, with the lower scene showing local shops at the harbourside.

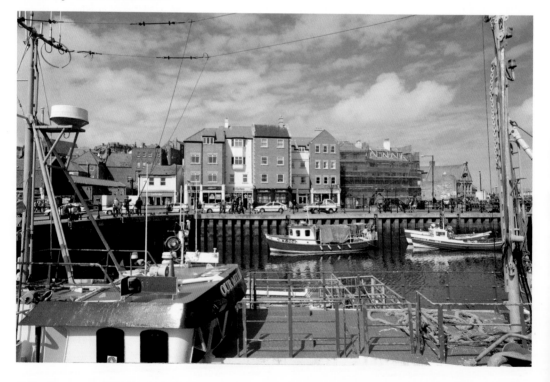

Following pages: Whitby Harbour..

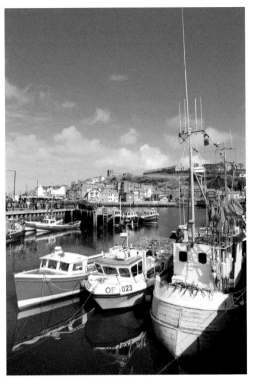

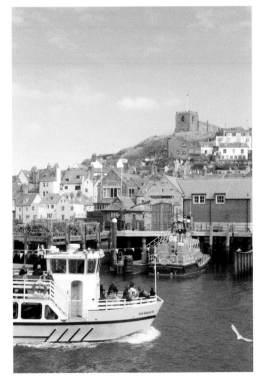

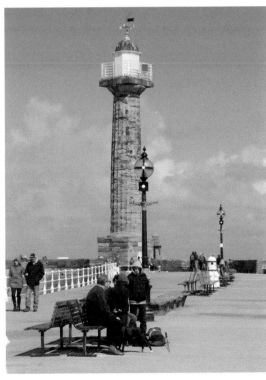

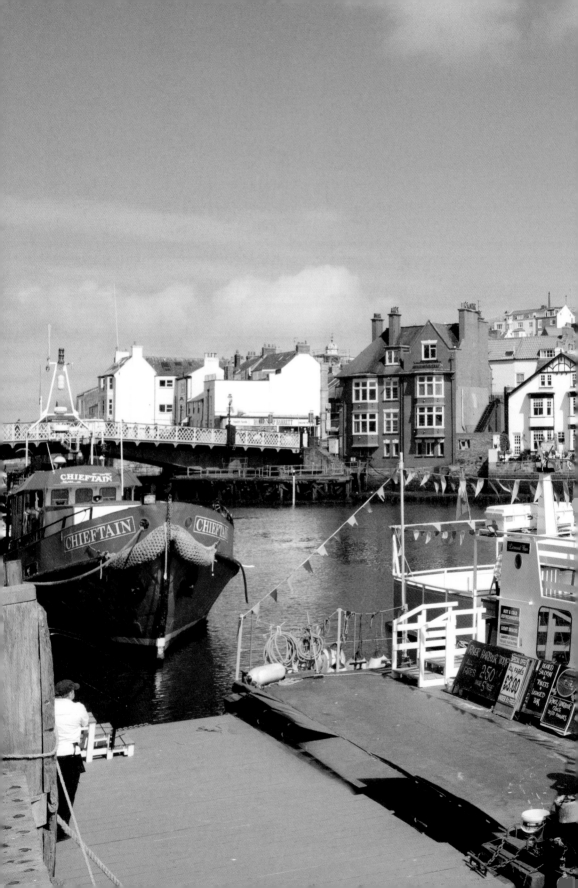

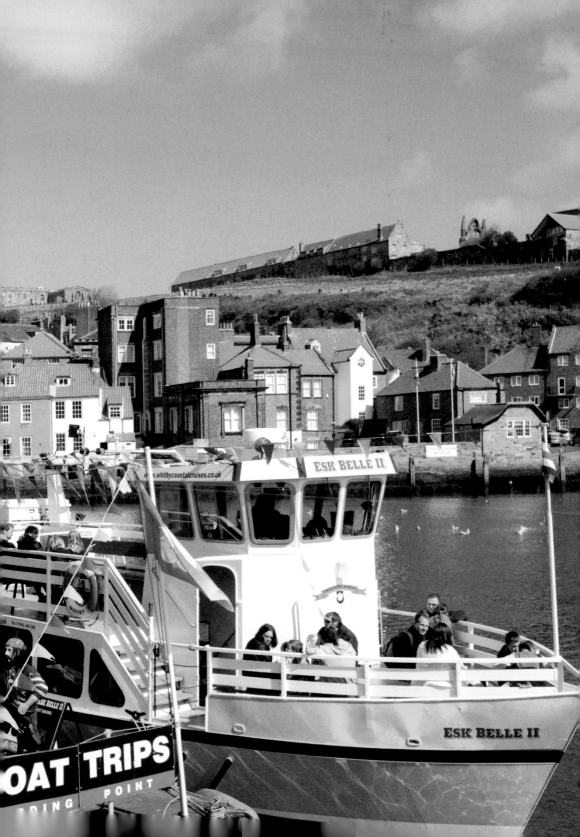

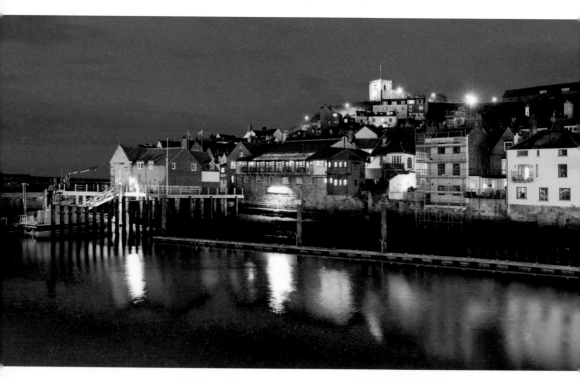

The harbour at night with the upper view showing an illuminated St Mary's church.

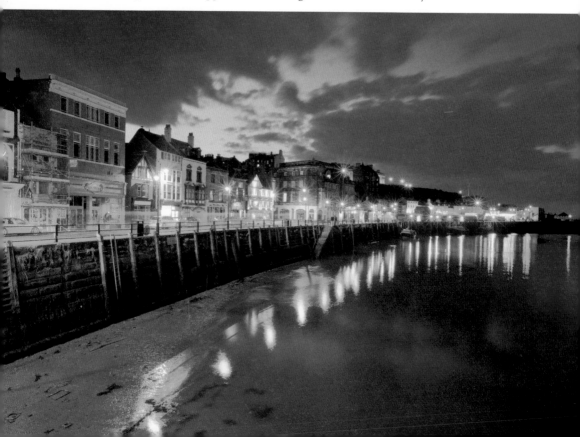

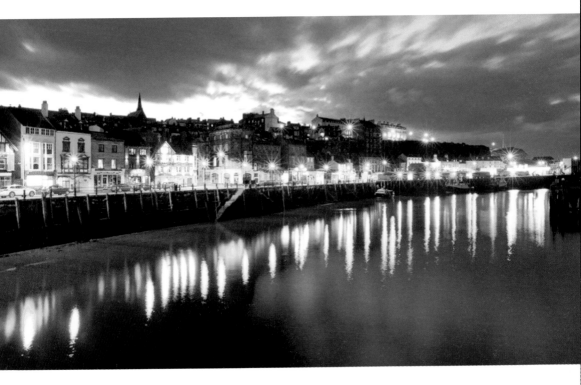

Night-time views of the pier and harbour.

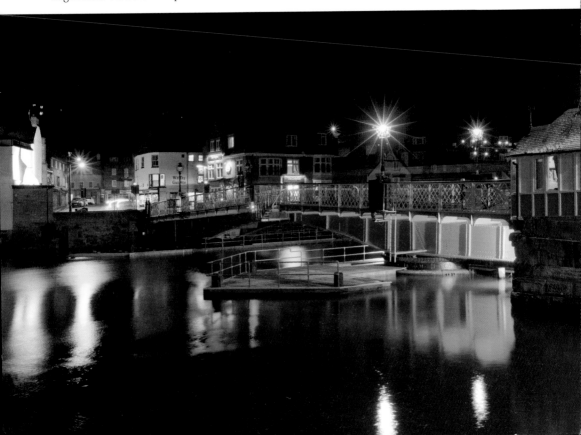

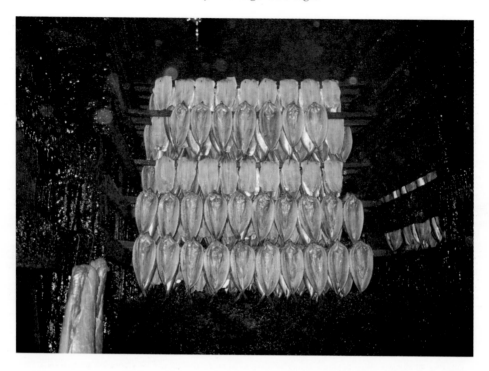

Inside one of the smoking sheds on the quay at Whitby. Herring are being prepared for smoking to make the famous Whitby kippers. At the end of 2012, landslips threatened the smokery here, the back of which was piled up with soil and debris from Aelfleda Terrace.

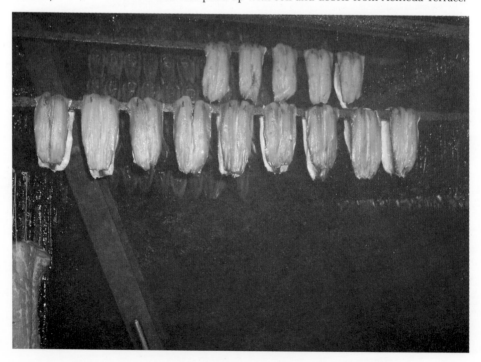

SEA WALLS

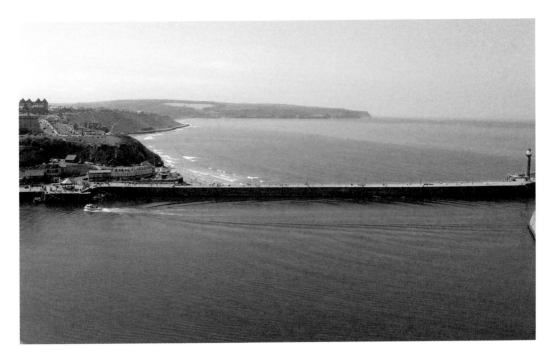

The harbour walls in 2005. These are now Grade II listed buildings

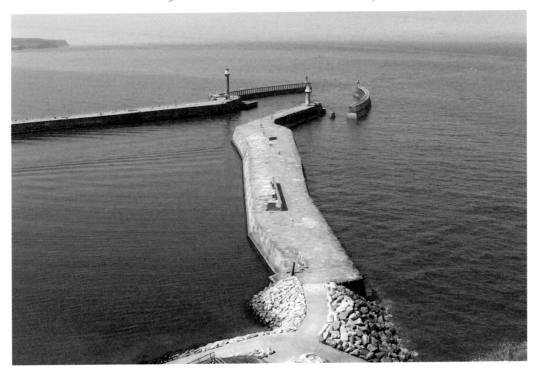

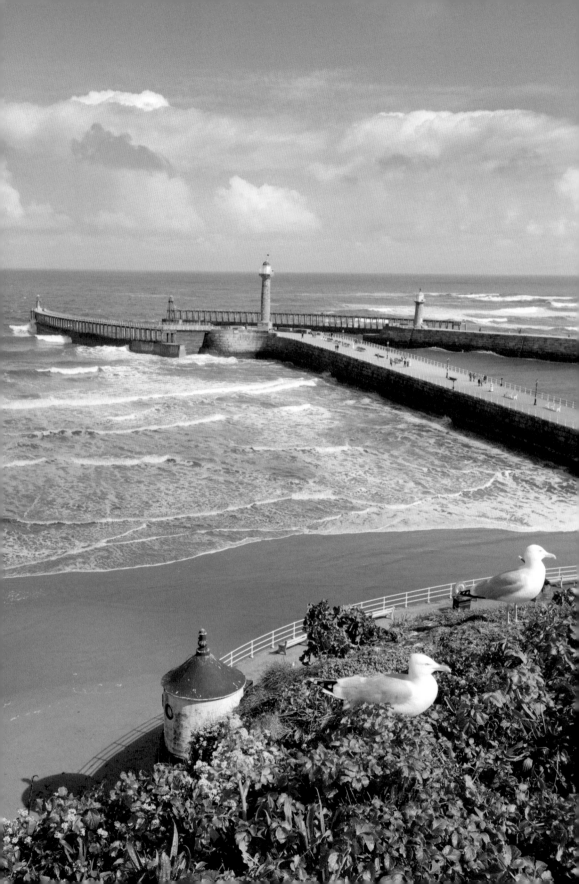

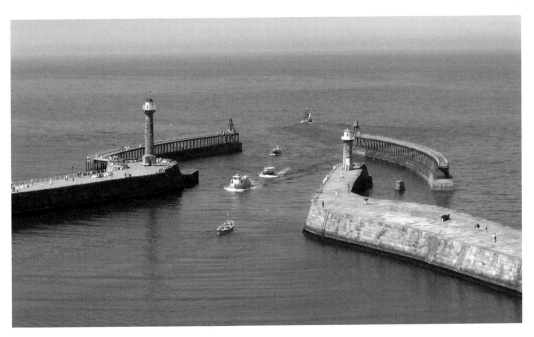

Views of the harbour mouth as it enters the North Sea.

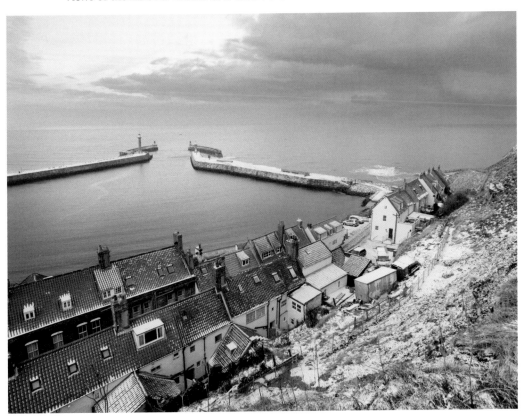

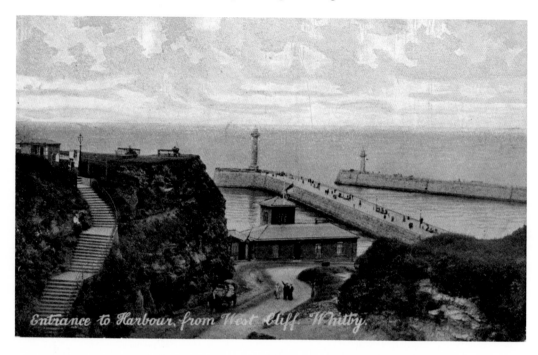

Entrance to Harbour from West Cliff, Whitby.

Above is the entrance to the harbour from West Cliff in the nineteenth century, while the lower view shows the harbour itself. Import taxes on goods entering Whitby harbour raised sufficient income to improve and extend the twin piers seen in these views and further increased trade by the mid-eighteenth century, making Whitby a wealthy place.

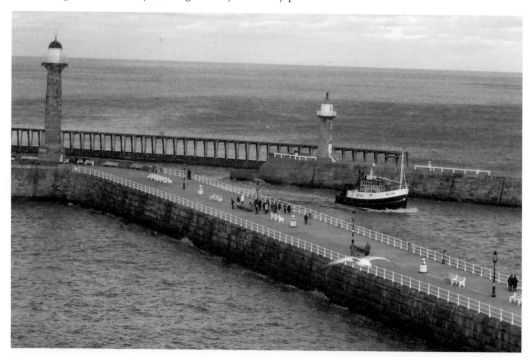

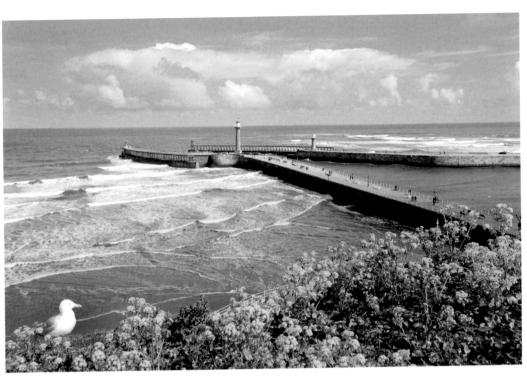

Popular with visitors is the sea wall, seen here in the summer.

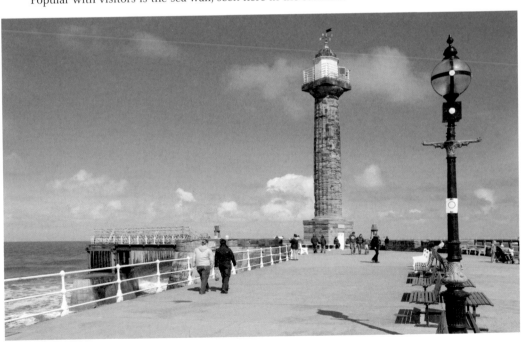

A close up of the lighthouse, as visitors and residents enjoy a stroll in the sun.

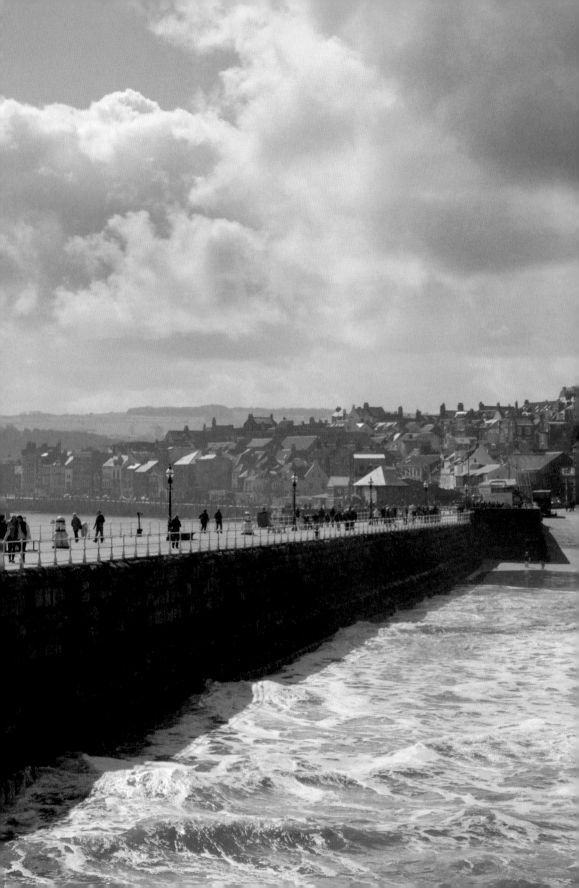

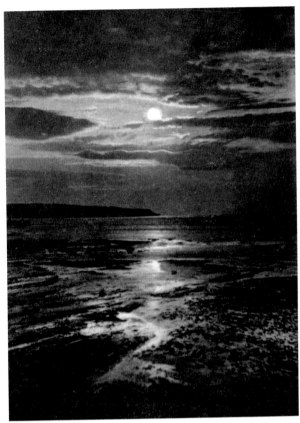

The view gives an impression of
the shoreline at Whitby in the
moonlight.

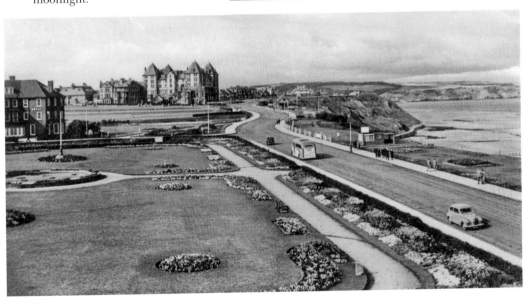

The north promenade at Whitby in the 1950s is featured in this view, with a motor coach and
Austin car of the period running along the road.

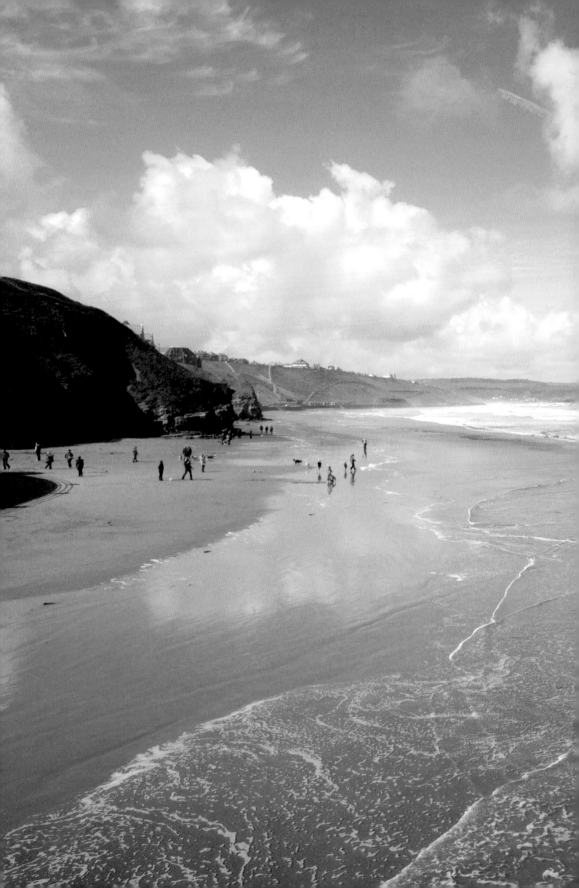

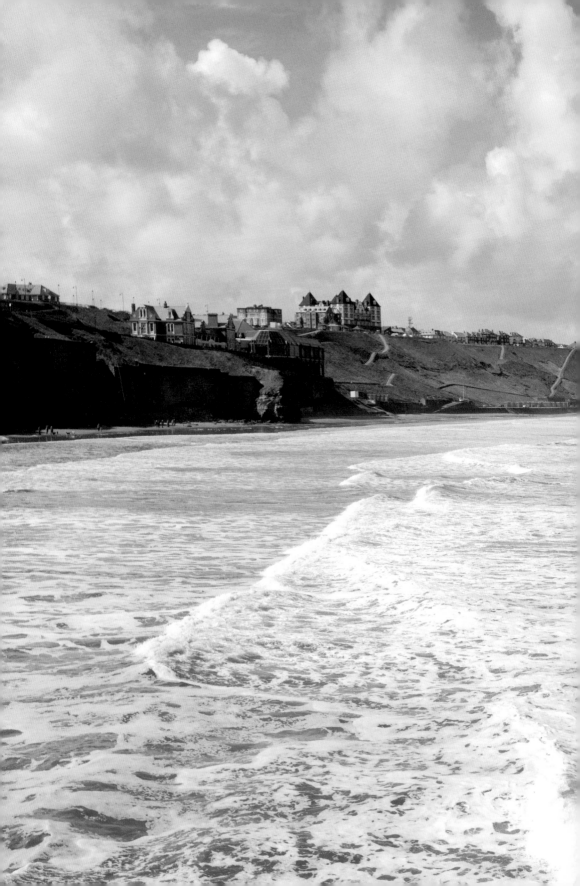

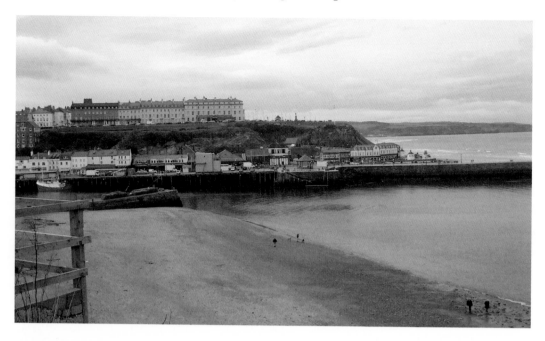

Two further views of this attractive seaside town. It is no wonder that Whitby remains so popular to this day.

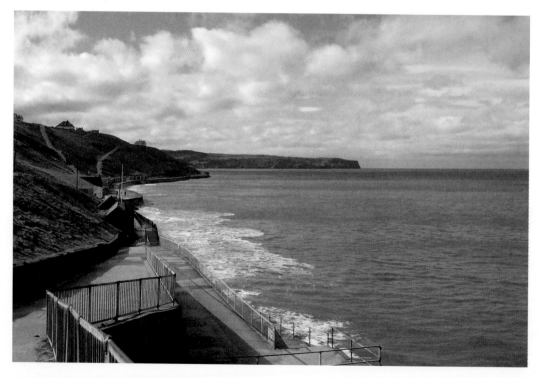

Previous pages: Seascapes of Whitby.

THE RIVER

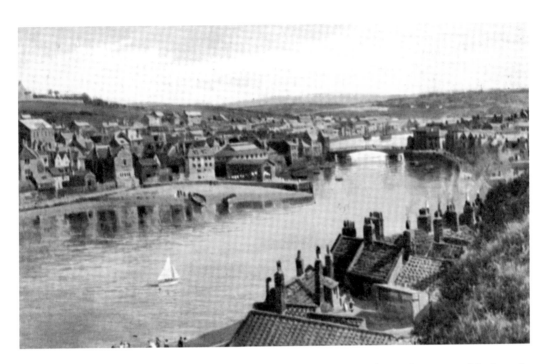

Whitby and the River Esk half a century apart. The upper view shows the town and harbour in the mid-nineteenth century, while the lower view shows the same scene in the 1930s.

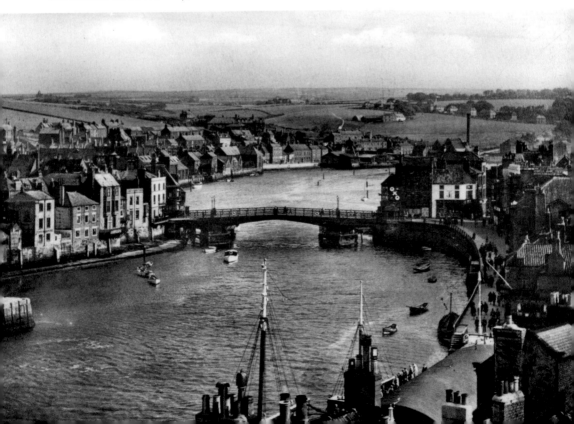

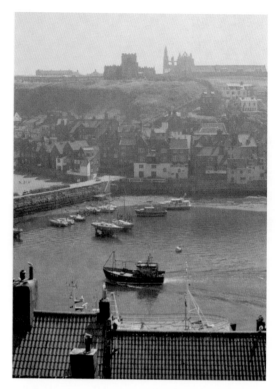

The harbour at Whitby with the abbey above and the town in between.

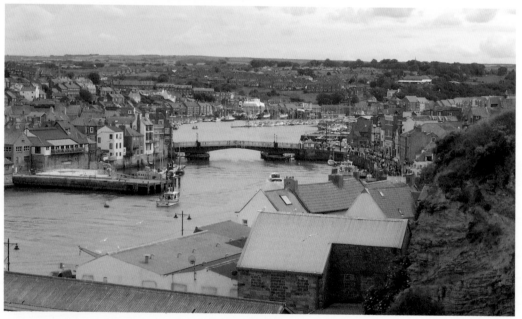

Pictured here, is the swing bridge, which links both parts of the town as it crosses the River Esk. The swing bridge allows ships to pass through for access to the inner harbour here and out to the North Sea.

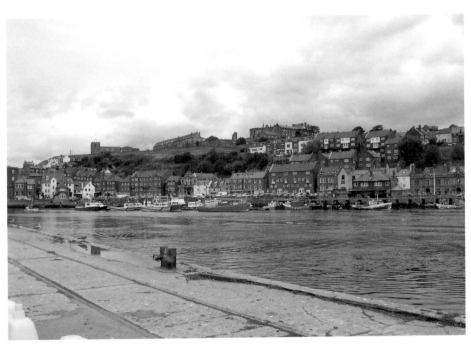

Views of the inner harbour on the River Esk at Whitby in 2005. Visible are the harbour, the swing bridge, the east and west sides of the town, and the hills beyond.

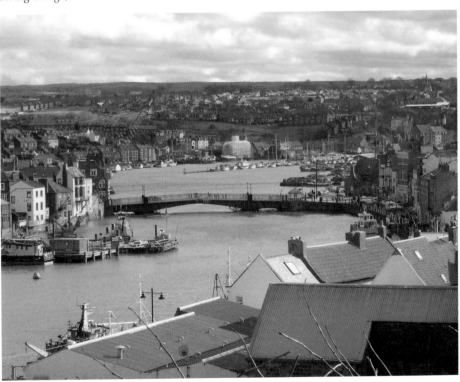

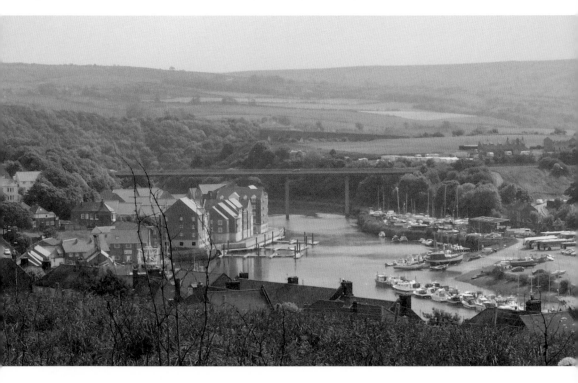

The upper view shows Larpool Viaduct in the distance beyond Whitby, while the lower view shows the viaduct in the 1950s when it was still in use by the railway. The viaduct was built as part of the Scarborough to Whitby line and was designed to link with the line from Whitby to Loftus, Saltburn and Middlesbrough, making a direct link between the industrial Teesside and the coast. The viaduct was the biggest engineering feature of the line and building was slow, work stopping altogether in 1877. Work was restarted in 1881 and the complete line was opened in 1885. The lower view shows the line from Whitby Town to West Cliff station passing underneath the viaduct.

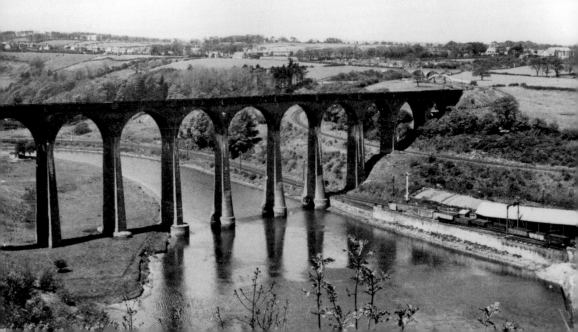

The Ghaul at Whitby in the early nineteenth century with the River Esk beyond. A fishing boat is in full sail leaving the harbour.

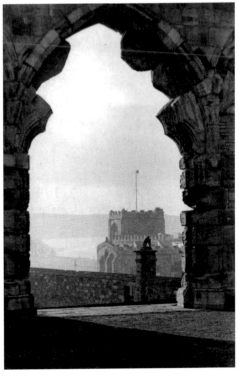

A view of St Mary's church from Whitby Abbey Arch in the 1930s with the River Esk in the background.

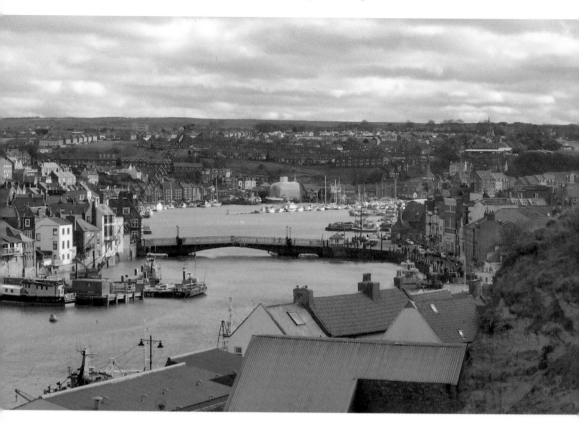

Further views of the river and Whitby in 2005. The Marina continues to be busy today, centuries after the town established itself as a working port.

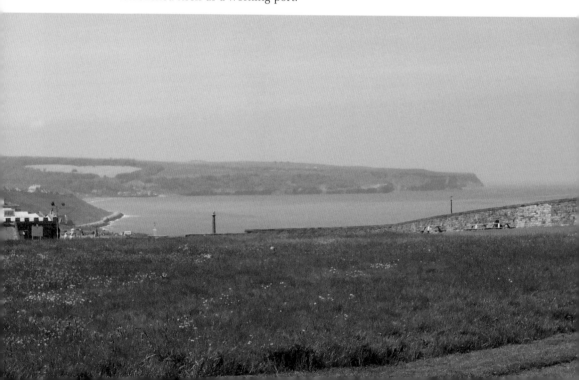

TALL SHIPS

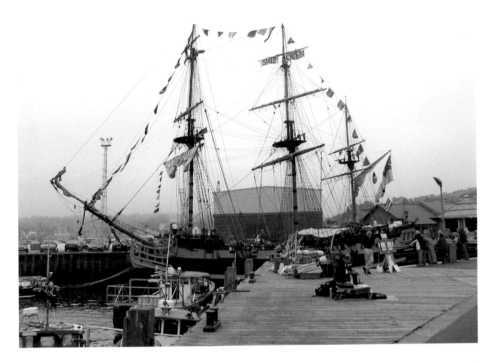

In July 2005, the tall ships visited Whitby as they made their way to Newcastle and served as a reminder of the importance of sailing ships to the town all those years ago. Here, two views of the *Grand Turk* are seen at the harbour. The ship was built for the television series *Hornblower* and was the HMS *Indefatigable* in the series.

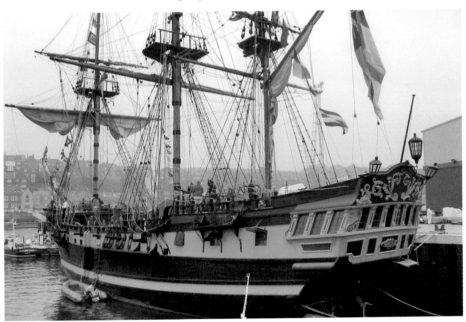

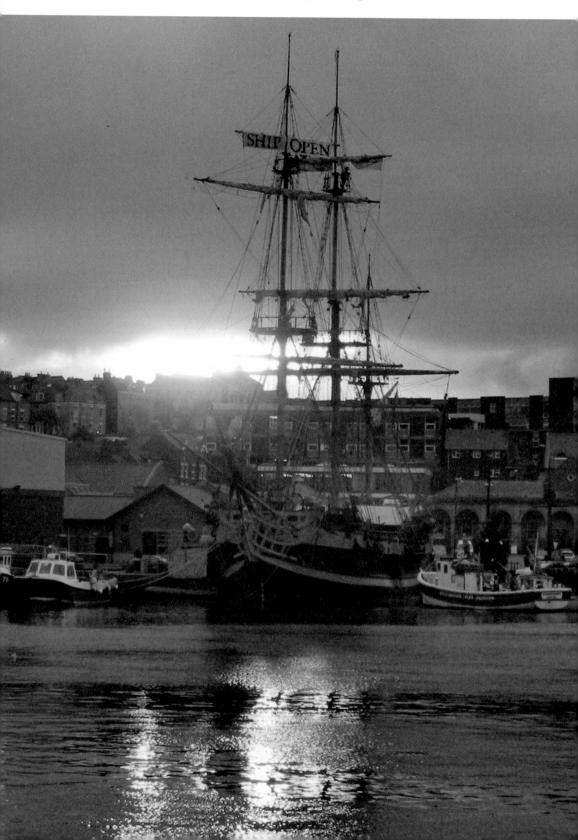

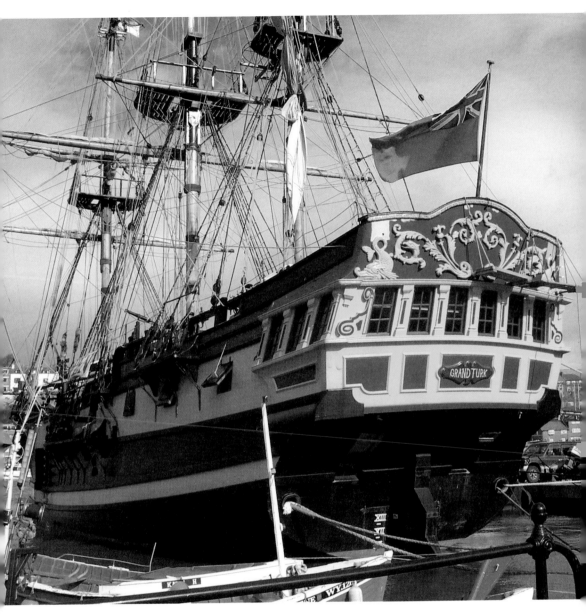

Rear views of the *Grand Turk* in 2005. The ship was the first British frigate to be built for more than 140 years and was the brainchild of Surrey boatbuilder Michael Turk, naval architect John Heath and marine engineer Ian MacDougal. Heath designed the ship after researching such vessels at the Maritime Museum, Greenwich. The 152-foot, 22-cannon frigate was built at the southern Turkish port of Marmaris, using traditional methods and over 200 cubic metres of iroko, a timber similar to that of mahogany. The *Grand Turk* is authentically rigged for sailing, but also has an engine. The ship can reach a speed of 10 knots under sail and more using its engines. When the *Grand Turk* entered the harbour in the July, all of her 22 cannons were fired which excited large crowds at the harbour. The image opposite shows the *Grank Turk* at rest in Whitby Harbour, with the setting sun in the backdrop.

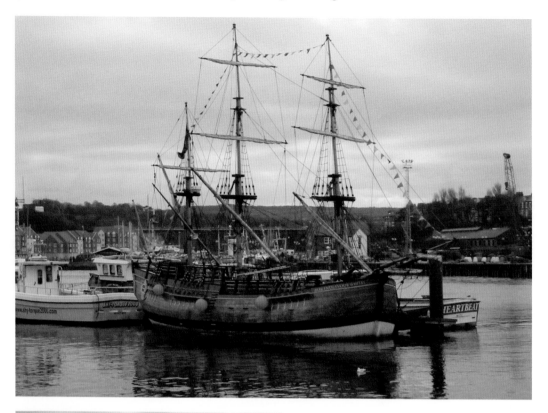

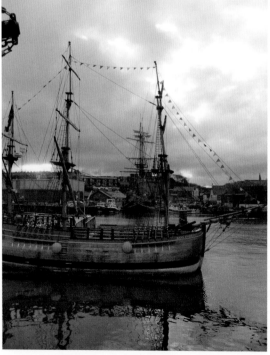

In 2003, the Australian – built replica of Captain Cook's ship HMS *Endeavour* visited Whitby and was greeted by thousands at the harbour, having first visited in 1997. She was accompanied by a flotilla of small boats as she entered the port. The upper view shows this famous replica at rest in the harbour before she returned to Australia. She is not likely to return to Britain again.

SWING BRIDGE

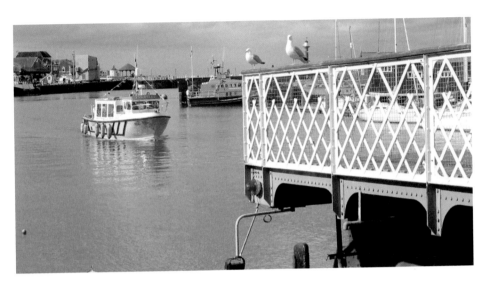

The swing bridge across the River Esk, which is open to allow a boat into the inner harbour. The swing bridge here divides the upper and lower harbours and joins the east and west sides of the town. By 1351, Whitby had become an important bridging point on the River Esk and tolls were taken for its maintenance. A survey was undertaken for a new bridge in 1609, and in 1628 it was described as a drawbridge where planks were raised to let ships pass and to collect tolls. The bridge posts were rebuilt in stone in 1766, at a cost of £3,000. The structure was replaced by a four-arch bridge between 1833 and 1835, one arch being of cast iron, which swivelled to let ships pass. This bridge was replaced in 1908/09 by the current swing bridge, which is electrically operated.

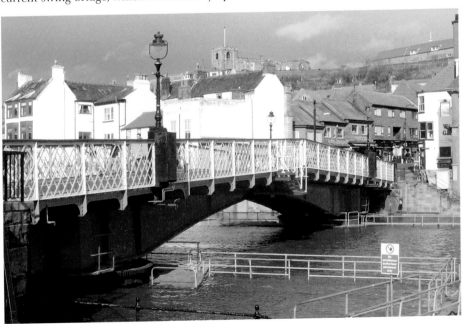

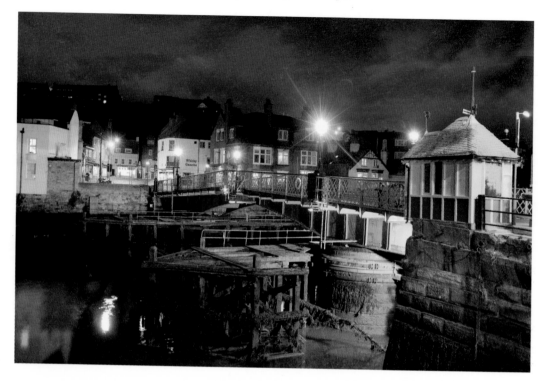

The swing bridge at night.

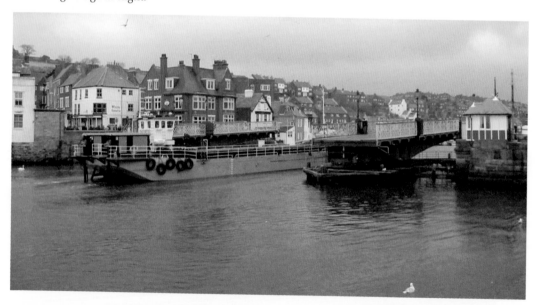

A view of a ship approaching the swing bridge across the River Esk to gain access to the inner harbour. In the early years of the twentieth century, the harbour was busy with the fishing fleet and very little cargo used the port. All this changed as a result of a strike at the Port of Hull in 1955 when six ships were diverted to Whitby and their cargo was unloaded on the fish quay.

MONUMENTS

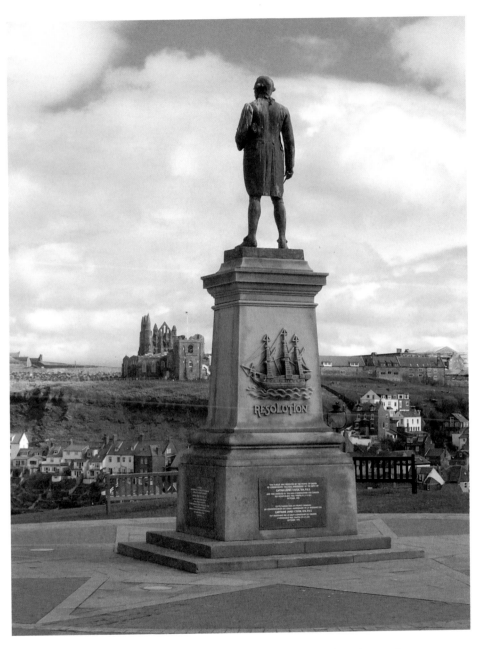

A of the statue of Captain James Cook, native of Whitby and seafarer, who went on to discover Australia and landed at Botany Bay, which he named because of the unusual flora he found there. The bay was to become well known as the place where transported convicts would have landed after they had been shipped from England. Along with Australia, Cook also mapped New Zealand and discovered the Hawaiian Islands, where he met his demise. Captain Cook's statue is in front of the Royal Crescent on West Cliff.

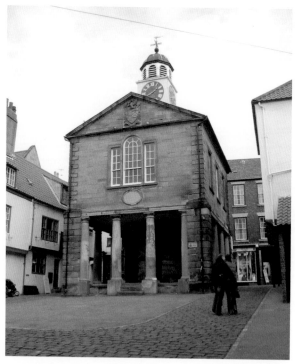

The old town hall, now a Grade II listed building and situated in the centre of the east side of town. The town hall served a board of improvement commissioners, who were elected by the ratepayers of the town under an Act of 1837. The board actually formed in 1872 and lasted until the Urban District Council was formed under the 1894 Local Government Act. The building here was recently refurbished by Scarborough Brough Council. An indoor and outdoor market is also located nearby.

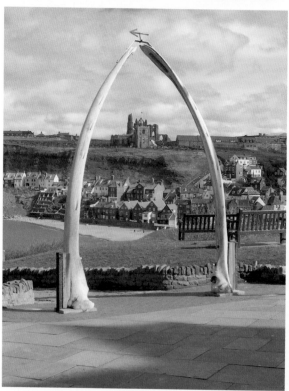

By 1795, Whitby had become a major whaling port following the first whaling ship to leave the harbour for Greenland in 1753. By 1814, eight whaling ships had caught 172 whales, making this the most successful year in the trade. The whaler *Resolution*'s catch yielded 230 tons of oil and the carcasses produced 42 tons of whalebones, which were used to make corsets. The whale blubber was boiled to make oil for lamps until the spread of gas made such oil redundant (which did much for the whale population). As demand for whale products declined, by the early nineteenth century catches became to small to be economic and only one whaling ship, the *Phoenix*, remained by 1831. The whalebones forming an arch in these views of 2005 remain as reminders of the once flourishing trade in whaling at the port some 200 years ago.

WEST CLIFF

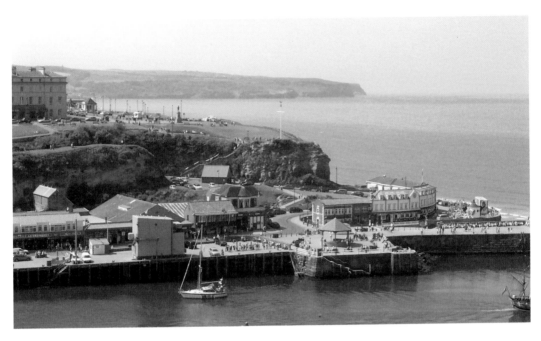

The harbour looking from East Cliff in 2005. The lower view shows the river and harbour with West Cliff in the distance on the same day. As can be seen, the town has grown substantially over the years. Indeed, in 1540 there were only 20 to 30 houses in Whitby and a population of around 200. It was the development of fishing, the coal trade and shipbuilding that allowed Whitby to prosper. Nowadays, it is tourism and fishing that are the mainstay of the town's economy.

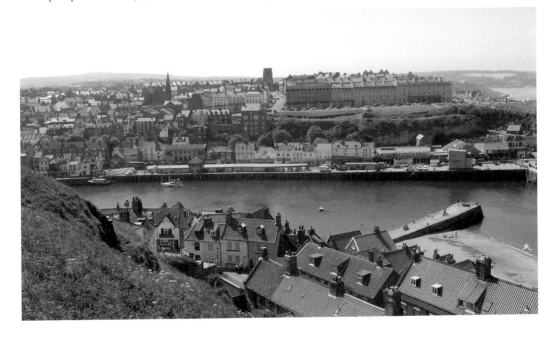

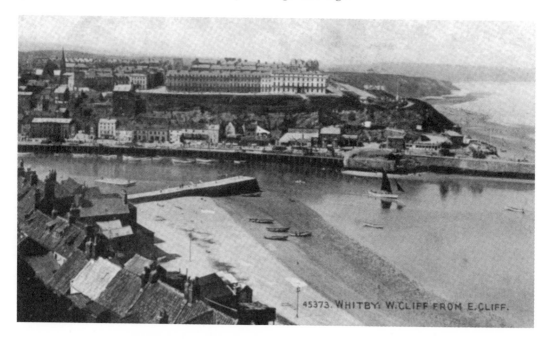

45373. WHITBY: W.CLIFF FROM E.CLIFF.

Further views of West Cliff in the late nineteenth century and the 1950s. George Hudson came to Whitby in 1843, when he was at the height of his railway speculation, and set up the Whitby Building Company, but it was not until 1848 that the company bought the whole of the West Cliff Estate. Construction began immediately; the first building to appear was the Royal Hotel, along with the East Crescent. The architect for the whole project was John Dobson, who had designed Newcastle Central railway station. Boarding houses followed at Langdale Terrace and Belle Vue Terrace, with four adjoining streets: John Street, Normanby Street, Abbey Terrace and Hudson Street.

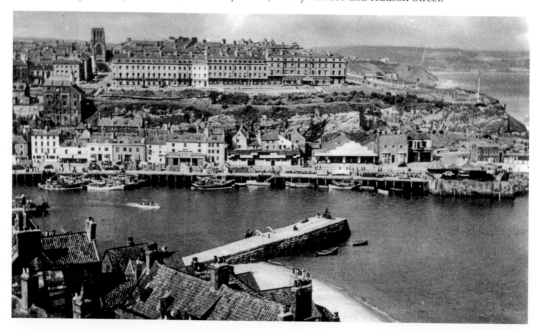

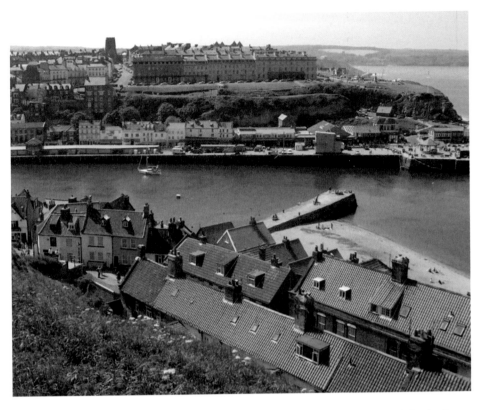

Two views of Whitby West Cliff: the upper view shows the area in 2005, while the lower view is from the early twentieth century. When the Y&NMR purchased the Pickering and Whitby Railway, its chairman, George Hudson, planned to develop the West Cliff area as a resort, thereby bringing extra traffic to his railway. The area, known as Cliff Fields, had been planned for development by local businessmen as early as 1827, but no progress was made.

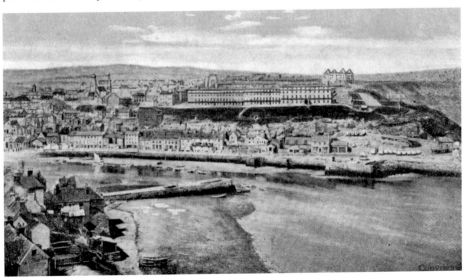

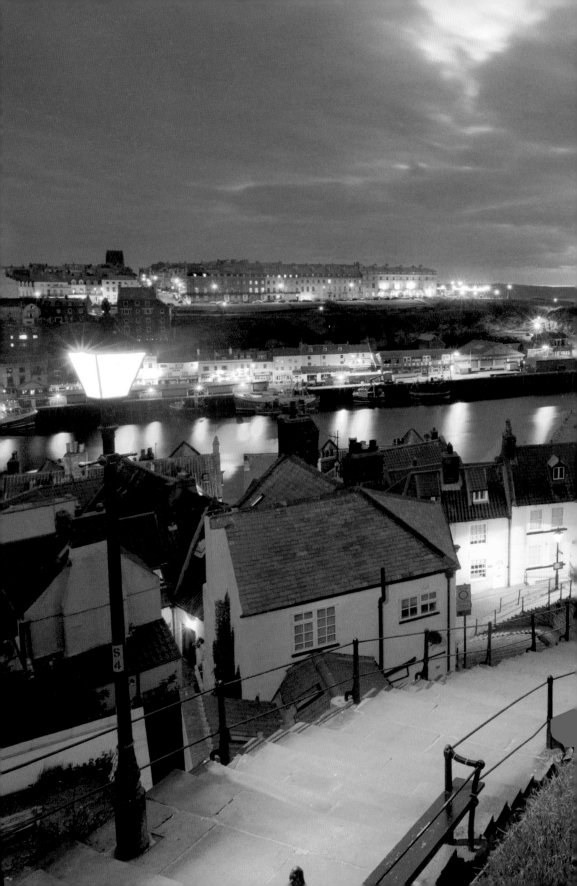

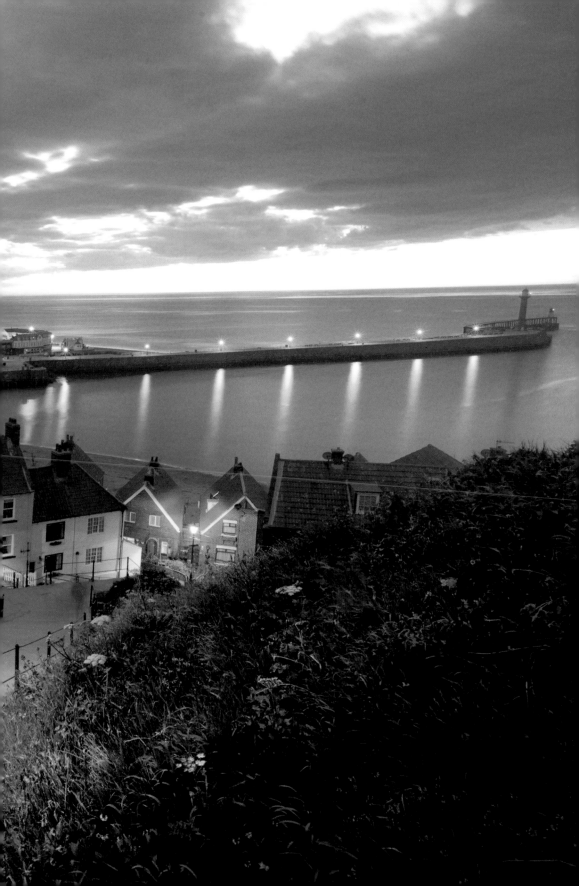

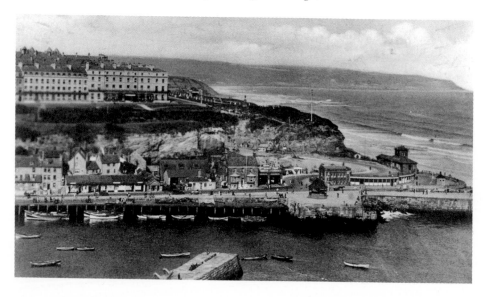

The upper view shows the harbour and West Cliff, a very popular viewpoint for postcards and photographs, and the lower view shows West Cliff promenade in the 1950s with what appears to be a Bedford OB coach on the road. A major part of Hudson's development plan was to build a seaward-facing crescent to rival that of Bath. However, he ran short of money before the project could be finished. Money was lent to him without ensuring that he could repay it and his railway empire was not giving the returns expected, subjecting his dealings to severe scrutiny. Hudson had used the West Cliff Estate as security and was declared bankrupt by 1849, thus his grand East Crescent was never finished and the half-completed structure still stands to this day. His dream, however, formed the basis of the holiday resort that was to follow. George Hudson sold his holding in the West Cliff Estate to Sir George Elliot, who built the spa complex and theatre, later used as a cinema.

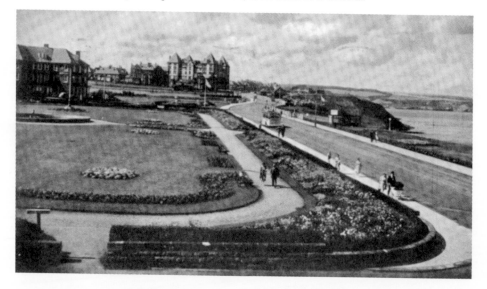

Previous page: West Cliff at night.

EAST CLIFF

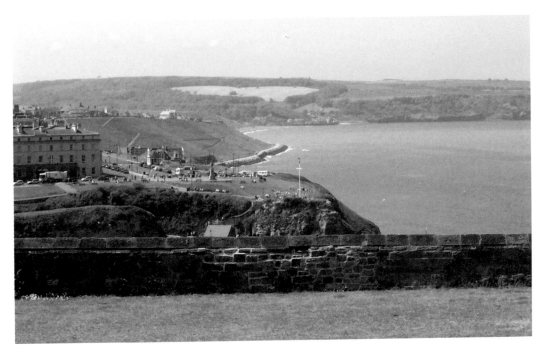

The bay at Whitby from East Cliff. The end of West Cliff is just in view.

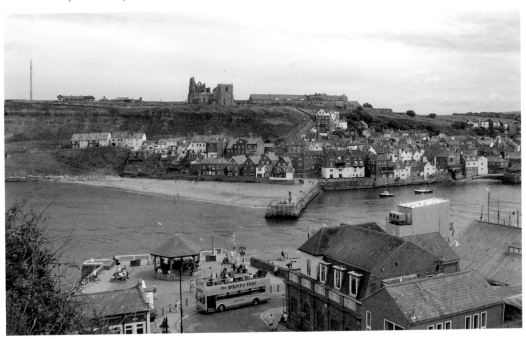

Here, East Cliff is visible, taken from West Cliff.

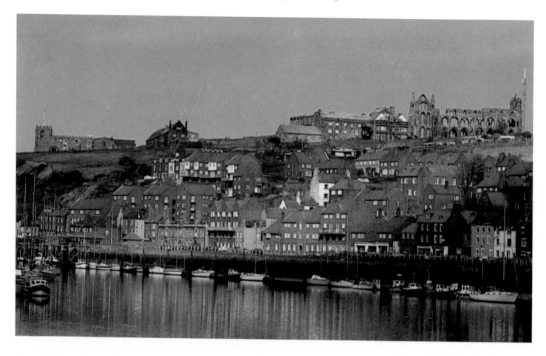

East Cliff in the 1950s and 1960s. Below the cliff, a maze of alleyways and narrow streets run down through the east side of town to the quayside. Due to extreme rainfall in 2012, a landslide caused the gardens at the back of a number of old jet workers' cottages in Aelfleda Terrace to drop by 30 feet. Continuous damage to the East Cliff made these nineteenth-century cottages unsafe and they had to be demolished. As there was no proper road access, and continued erosion, the cottages had to be demolished brick by brick. Owners of the cottages were asked to pay £40,000 each by Scarborough Council for demolition costs, adding insult to injury.

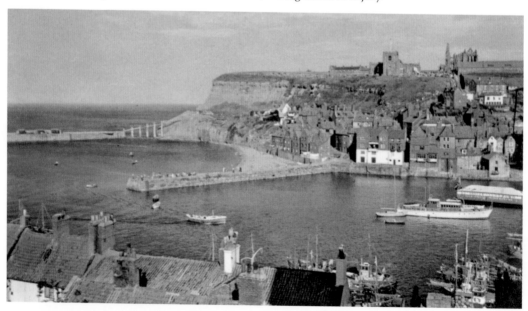

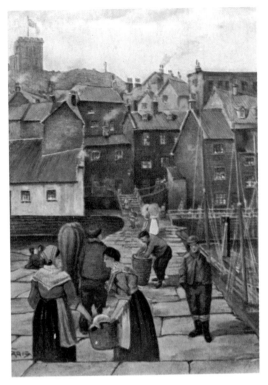

Early nineteenth-century views of Whitby. The upper view is of East Cliff with the harbour in the foreground and a local church tower in the background. Below is Church Street, on the opposite bank of the River Esk, during the same period.

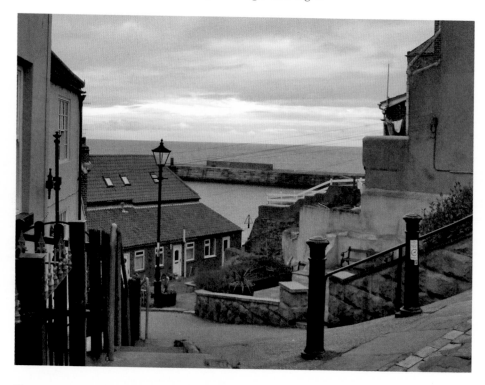

The upper view shows the harbour walls looking down from East Cliff, while a general view of the harbour is seen in the lower view.

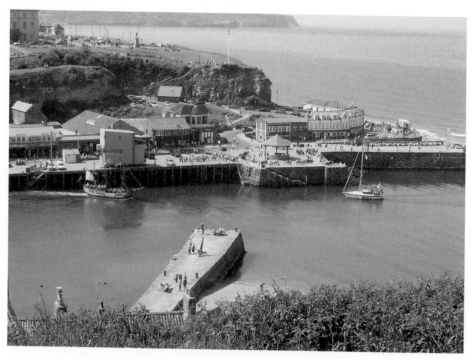

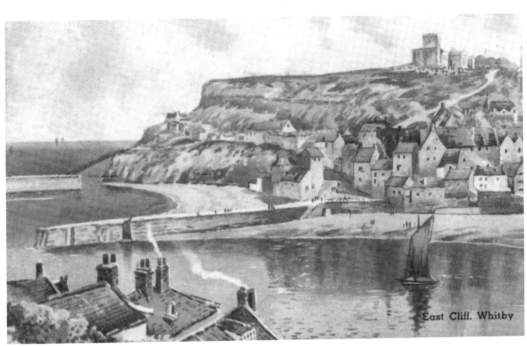

The upper picture gives an impression of East Cliff in the early eighteenth century before St Mary's church was built. The lower view shows East Cliff in the late nineteenth century with the abbey and St Mary's church at the top of the cliff.

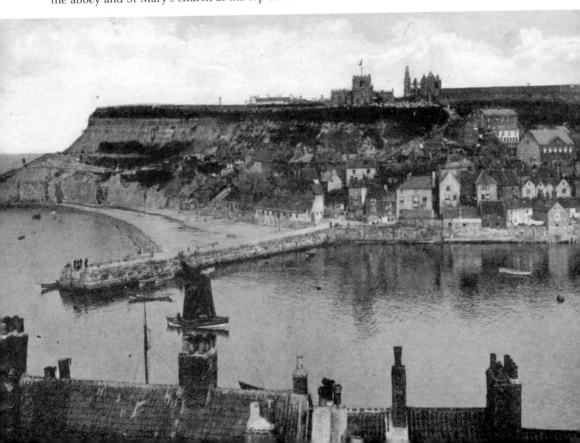

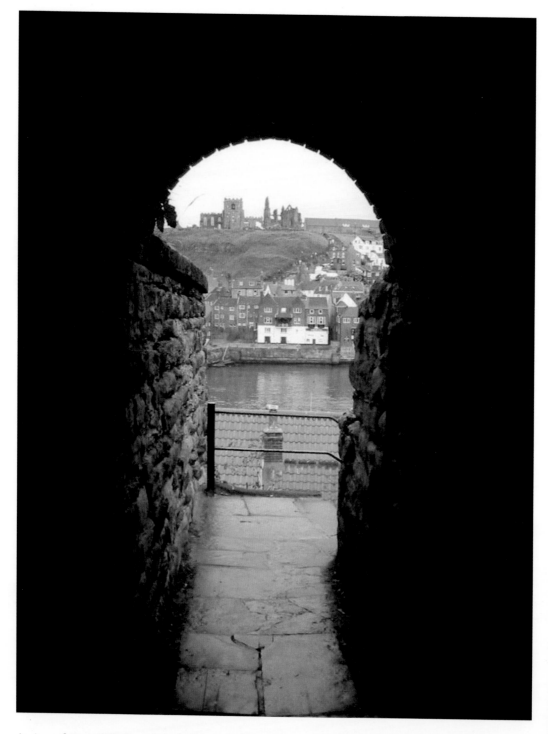

A view of East Cliff, the abbey and St Mary's church from the passageway, which links 'Khyber Pass' with the main town, approached from steps that descend on the right of the tunnel mouth.

ST MARY'S CHURCH

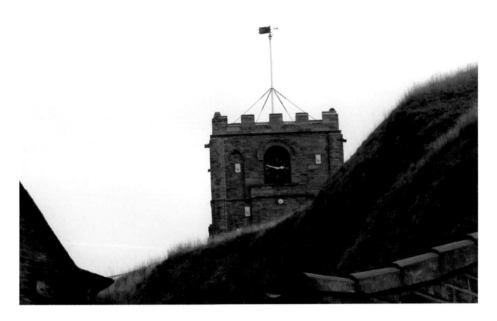

The upper view shows the tower of St Mary's church in 2005 and the lower view is of the graveyard that gave Bram Stoker the inspiration for his famous Gothic novel *Dracula*, thought to be influential to the 'Goth' subculture many years later. It is said that Dracula arrived in Whitby by ship from Transylvania. In January 2013, landslips put the graveyard at St Mary's church in great danger, but thankfully the land here was stabilised.

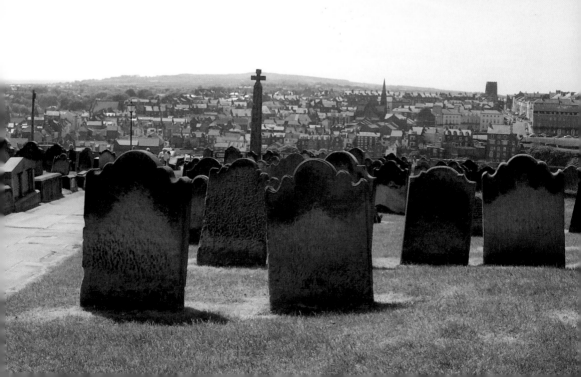

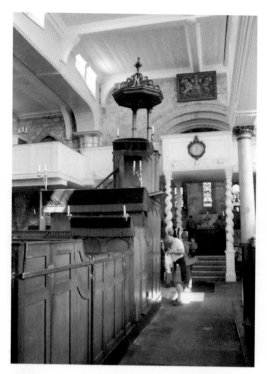

The interior of St Mary's church with the family pews in situ. St Mary's church is of ancient origin and has its own bishop, part of the Diocese of York.

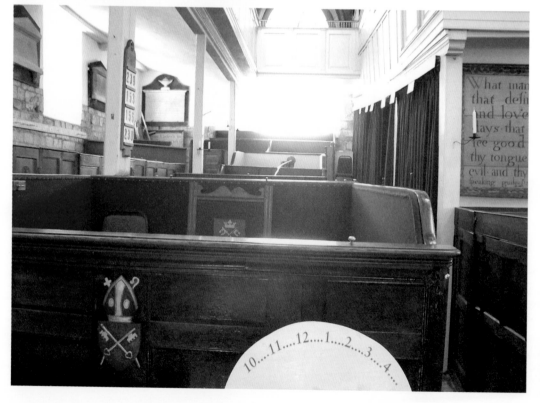

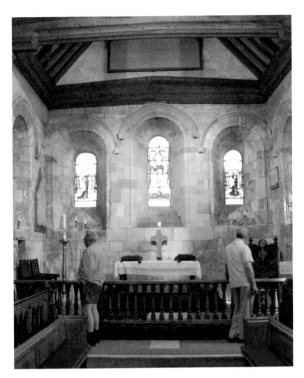

The main body of the church, with
its gallery running along the walls;
the spiral columns are also in view.

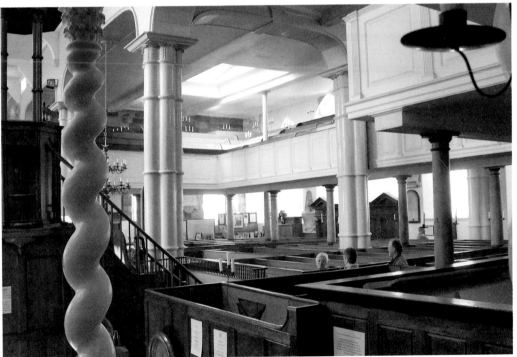

The altar at St Mary's church is seen with stained-glass windows above.

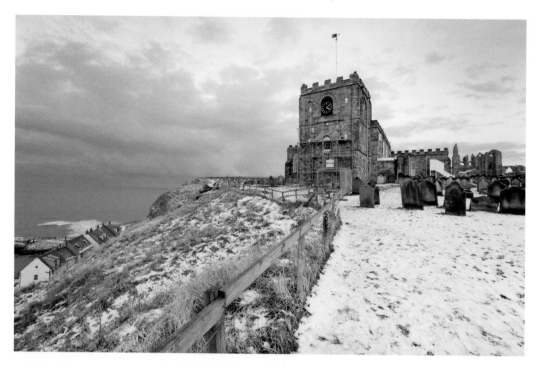

Two views of the church at different times of the year. The upper view is a snowy winter scene, while the lower gives a little more edge with the night-time atmosphere.

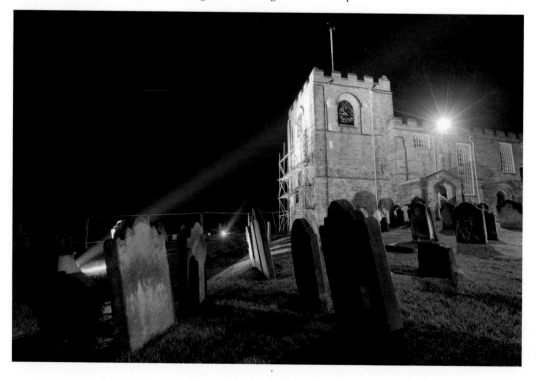

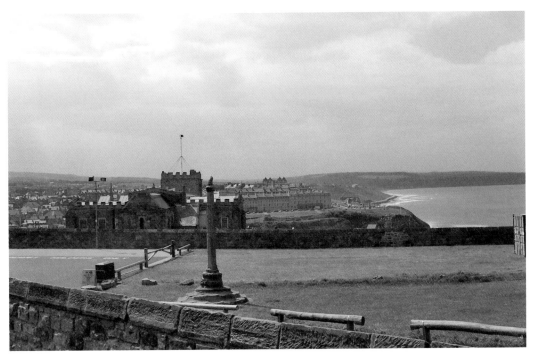

Along with the abbey, St Mary's church is also situated on the East Cliff, as the upper view shows. The lower view shows the exterior of the church with its tower. The church is reached by climbing 199 steps from Henrietta Street.

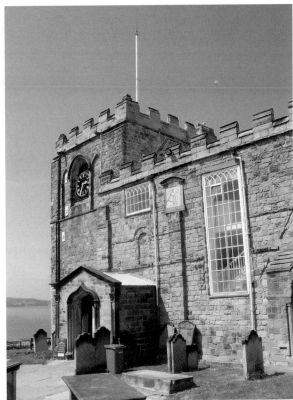

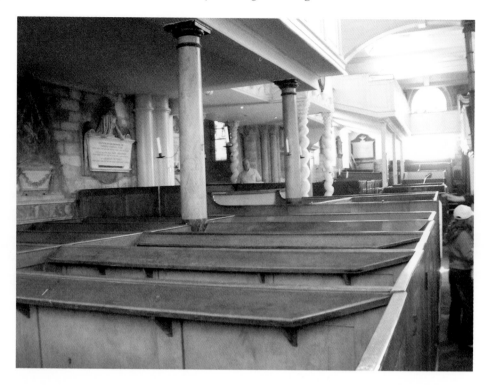

Two further views of the interior of St Mary's church, showing columns supporting the roof and the family pews.

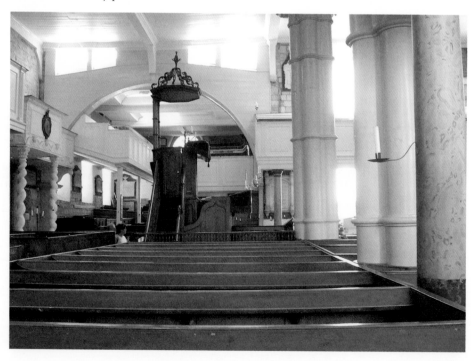

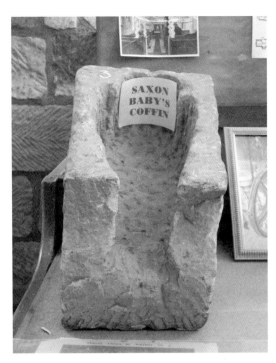

An Anglo-Saxon baby's coffin made of stone.

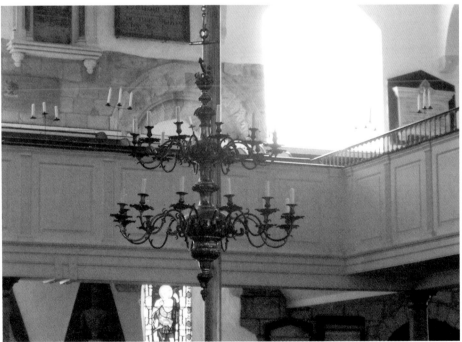

The gallery around the walls at St Mary's church and the chandelier, which would have held candles in former years to light the church, although the holders now contain electric lightbulbs in the shape of candle flames.

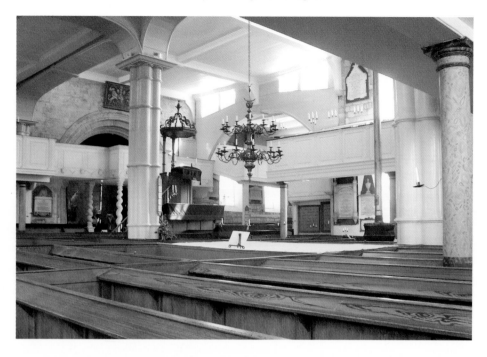

A final view of the interior of St Mary's church in 2005.

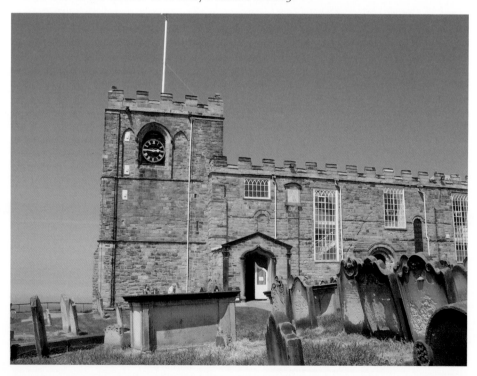

The graveyard is another well-known view, containing graves of residents through the ages.

WHITBY 'GOTHS'

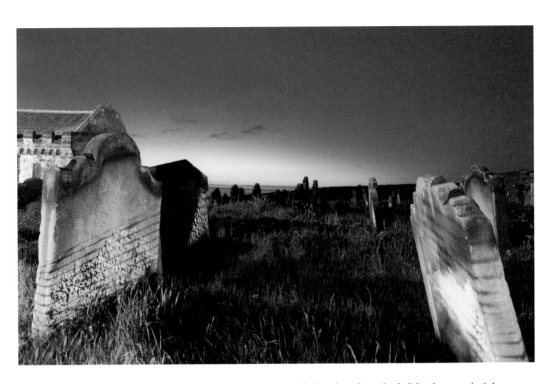

The graveyard at St Mary's church in the evening with the church in the left background of the upper view and the abbey in the lower view. But who does the shadow on the gravestone belong to?

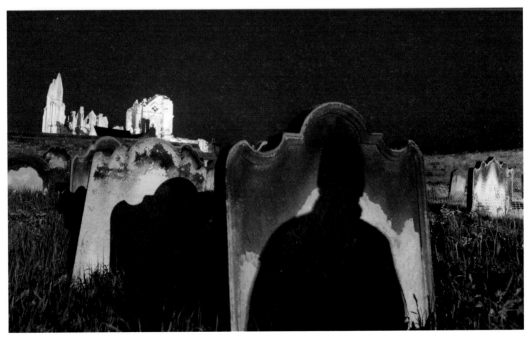

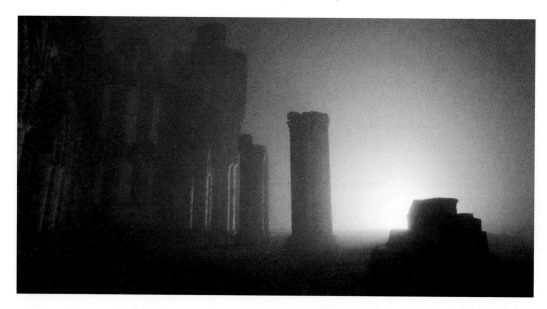

The abbey and town hidden in sea mist, giving the town something of a 'spooky' feel. Along with the Dracula legend, the atmosphere creates a 'Gothic' image, giving good reasons as to why the town is popular with 'Goths', who enjoy two festivals a year, in April and October. These events originally began with one a year in 1994, expanding to two in 1997, and remain very popular to this day.

Opposite page: An impression of Count Dracula – one of the reasons for the popularity of Whitby as a resort.

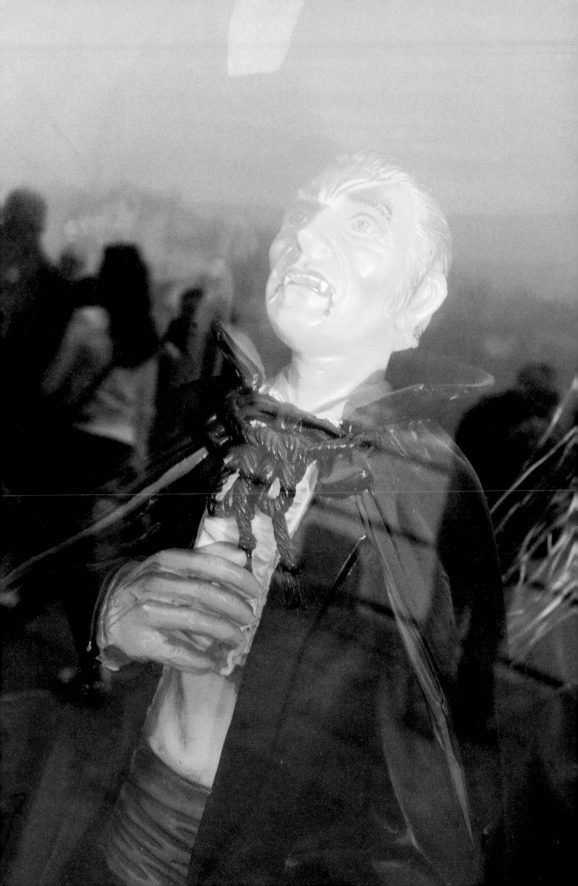

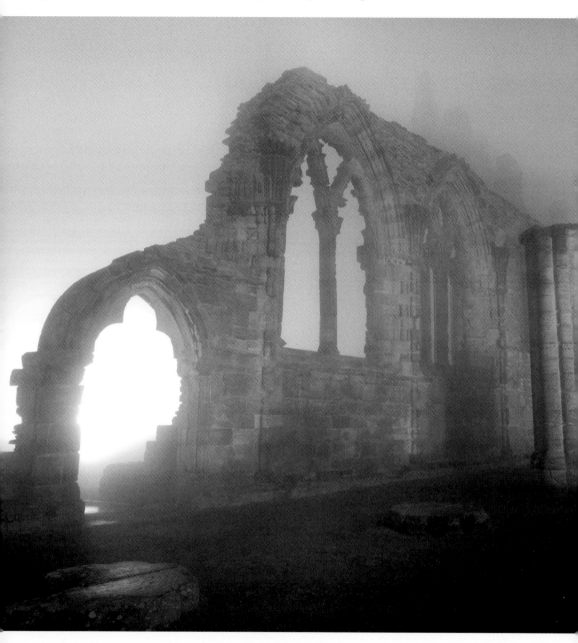

An atmospheric view of the ruins of Whitby Abbey shrouded in sea mist.

WHITBY ABBEY

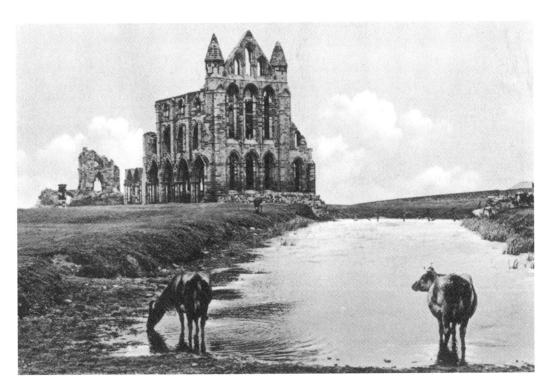

Whitby Abbey from the south-east at the end of the nineteenth century, with cows taking water from the stream nearby.

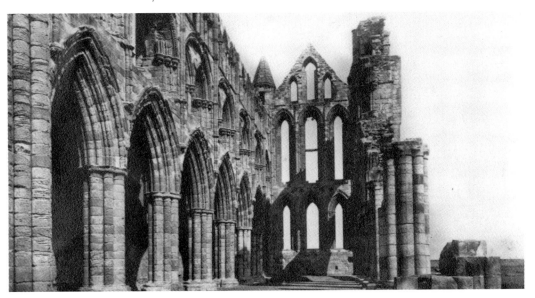

The abbey in the same period, looking east.

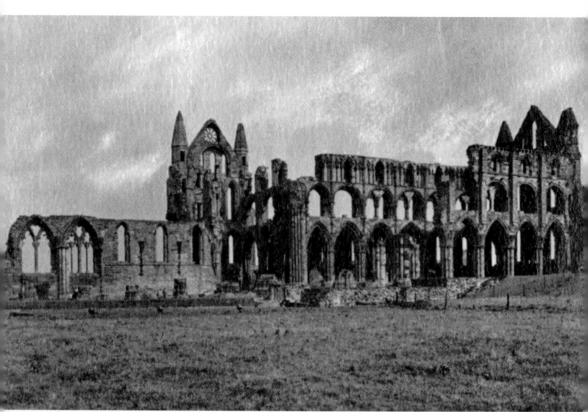

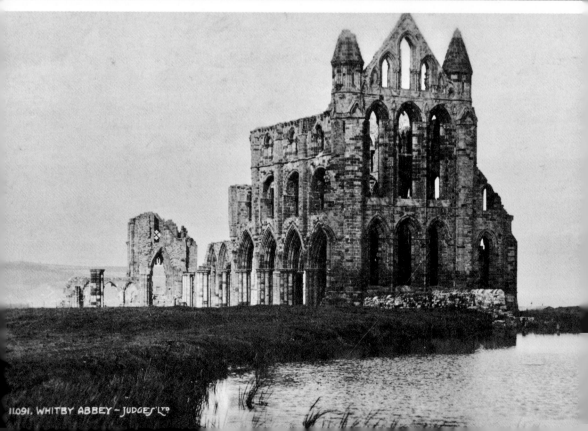

11091. WHITBY ABBEY - JUDGES'L??

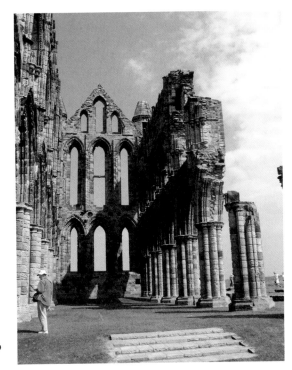

The ruins of Whitby Abbey in 2005. A monastery had long been founded here, as early as AD 657, by King Oswy of Northumbria as an act of thanksgiving following his defeat of the pagan king of Mercia. When it was founded, it was a double monastery for both men and women, its first abbess being the royal princess Hild, who was later venerated as a saint.

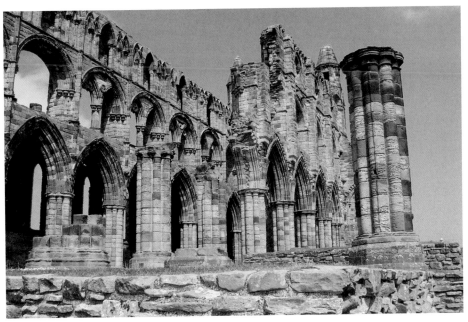

Further ruins of Whitby Abbey in 2005. The original abbey became a centre of learning and was to become the leading royal nunnery of the Kingdom of Deira, and the burial place of its royal family. The Synod of Whitby in AD 664 established the Roman date of Easter in Northumbria at the expense of the Celtic one.

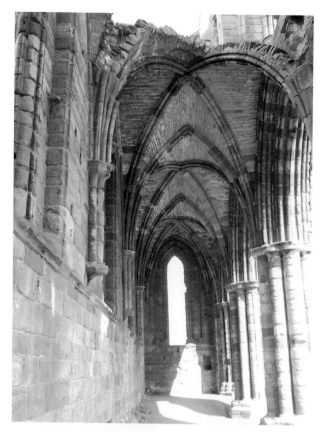

Views of the abbey in 2005. The original monastery was destroyed between 867 and 870 following a series of Viking raids, under their leaders Ingwar and Ubba. The site remained derelict for more than 200 years until after the Norman Conquest.

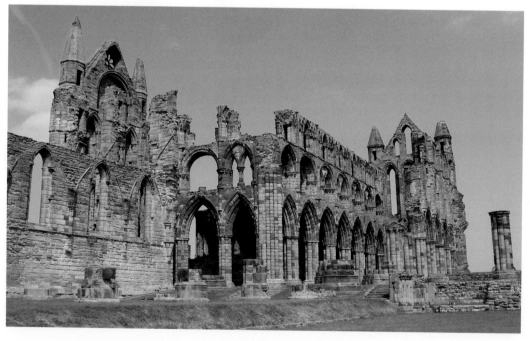

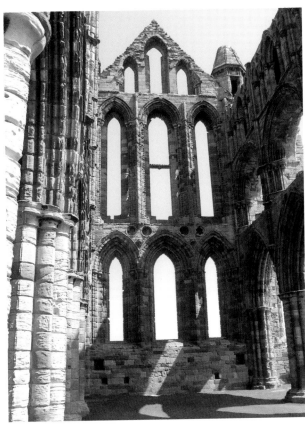

Exterior views of the abbey in 2005.

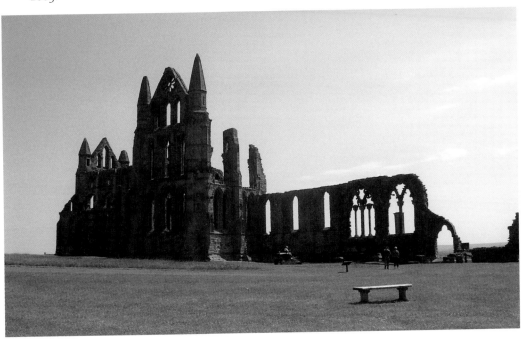

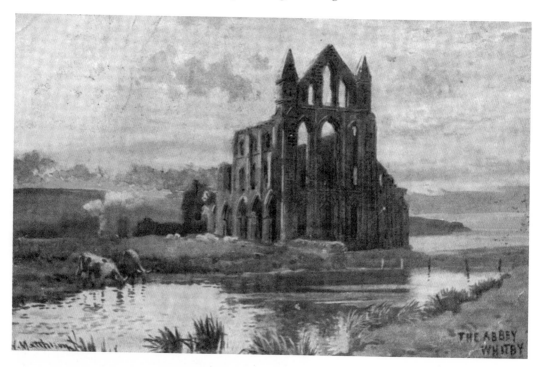

Views of Whitby Abbey in the nineteenth century. As seen previously, the abbey is situated on the East Cliff and was founded after the Norman Conquest of England when William de Percy donated land in 1078 to found a Benedictine monastery dedicated to St Peter and St Hilda.

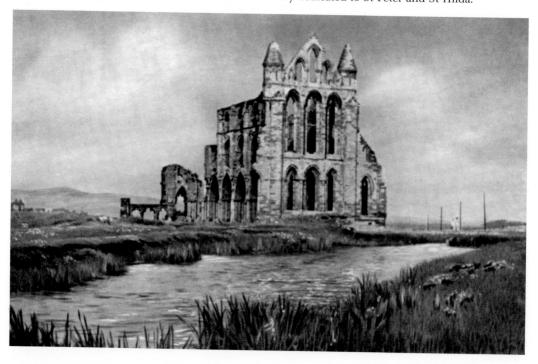

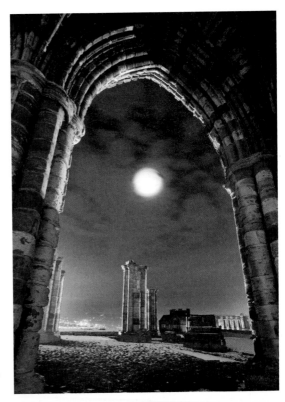

Whitby Abbey in the evening and under moonlight.

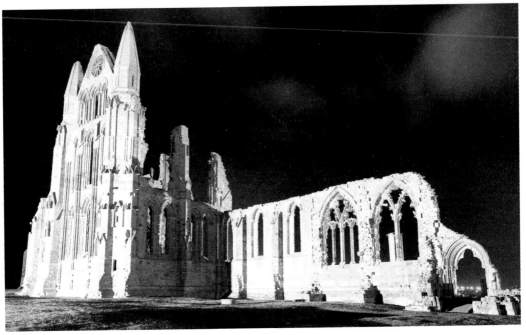

The abbey at night is an inspiring sight.

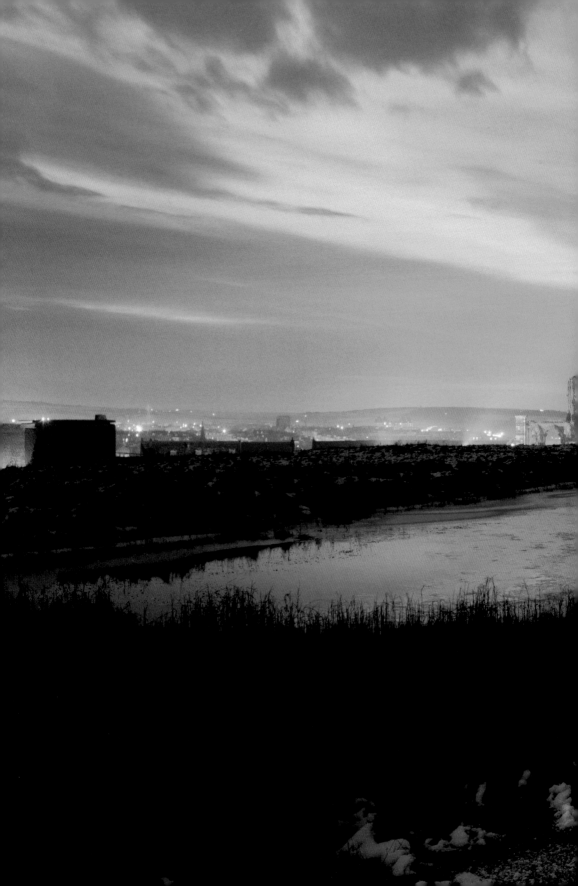

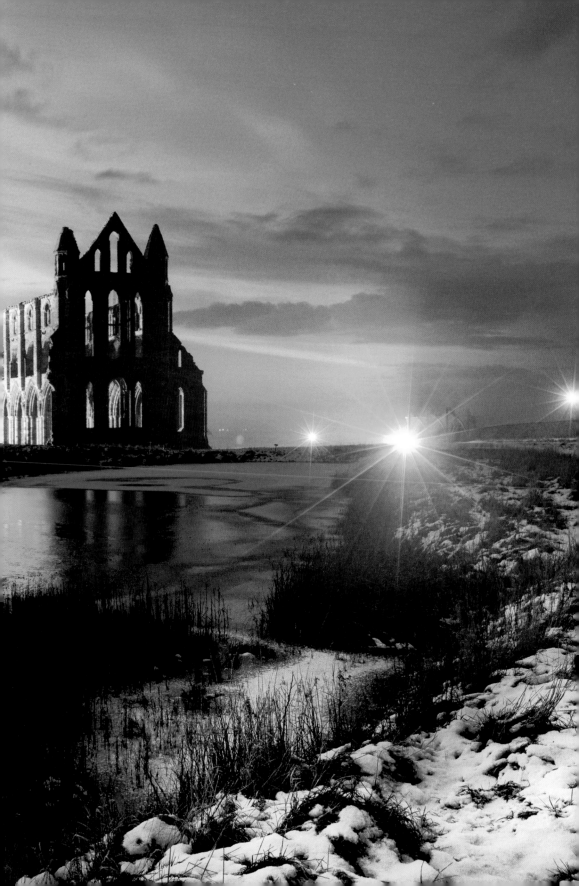

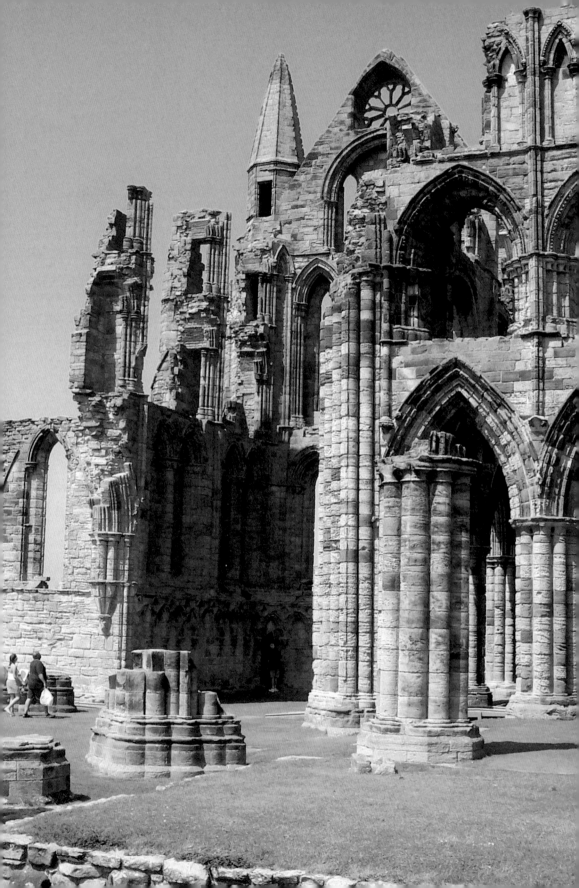

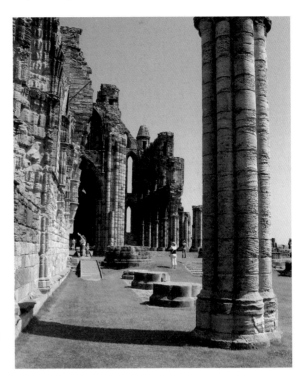

The upper view shows columns at the abbey, while the lower view shows gravestones in the grounds.

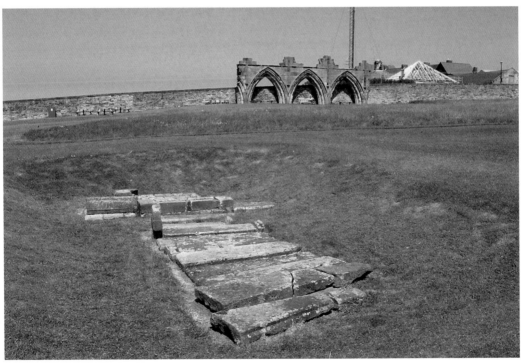

Previous pages: The spectacular ruins of Whitby Abbey at night and in the summer of 2005.

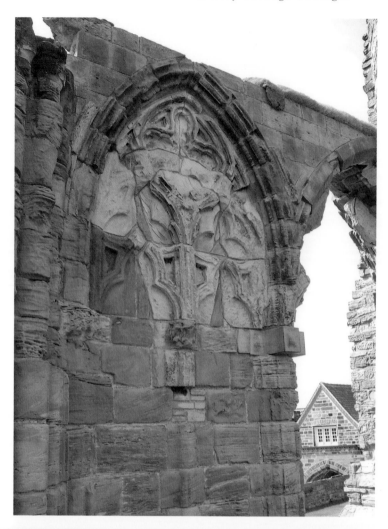

Further views of the
Abbey in 2005.

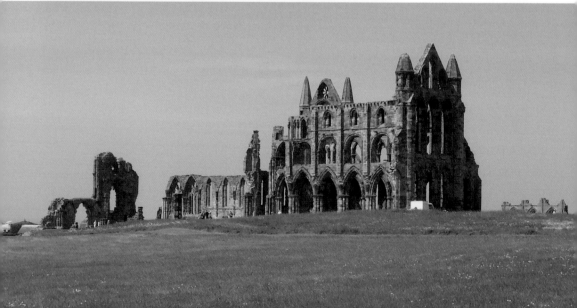

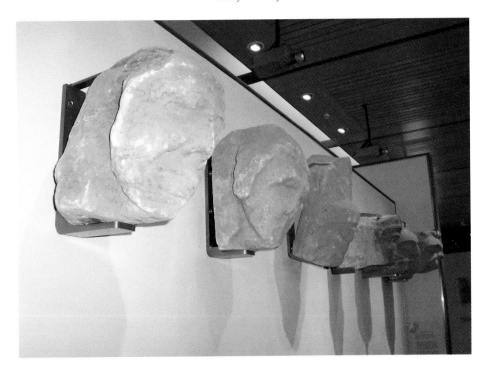

The gargoyles pictured here are located on the walls inside the visitor centre, next to the abbey. They were rescued from the ruins.

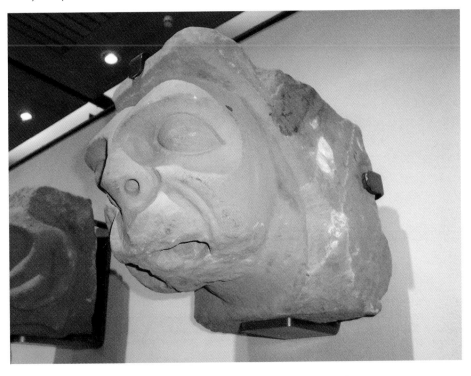

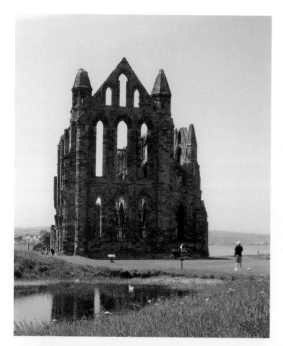

William de Percy's gift included land for the monastery, the town and port of Whitby, and St Mary's church, along with chapels at Fyling, Hawsker, Sneaton, Ugglebarnby, Dunsley and Aislaby. Five mills were included at Ruswarp, and Hackness had two mills and two churches. The abbey was granted permission to hold a fair by Henry I in 1128, at the feast of St Hilda on 25 August, with a second fair being held close to St Hilda's winter feast at Martinmas. Market rights were also given by the King. When Henry VIII dissolved the monasteries, Whitby Abbey held out until December 1539, after which there was much destruction, not helped by the shelling in 1914.

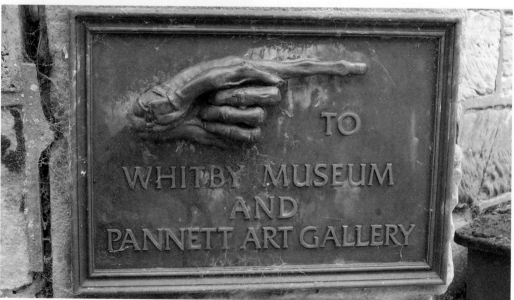

The signpost for the Pannett Art Gallery and Museum. The hand that points the way could be seen as the symbol of the severed hand that was discovered in the early twentieth century, hidden on the wall of a thatched cottage in Castleton and now in the museum. It was identified as a 'Hand of Glory', a supposedly pickled right hand of a felon while he still hung from the gallows, which was supposed to be used by burglars to send sleepers in the house into a coma so that they could go about their 'business' unmolested. The hand was presented to the museum in 1935 and, as far as is known, is the only such hand to survive.

OLD WHITBY

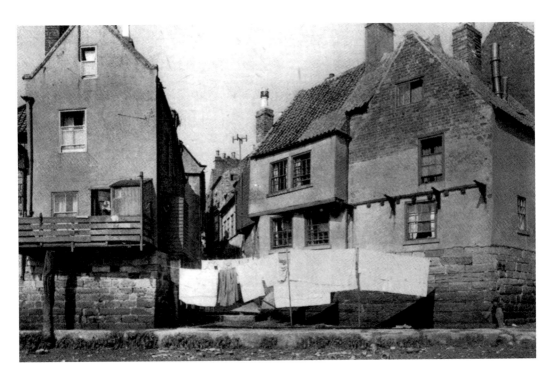

'Old Whitby' as it appeared in the 1930s.

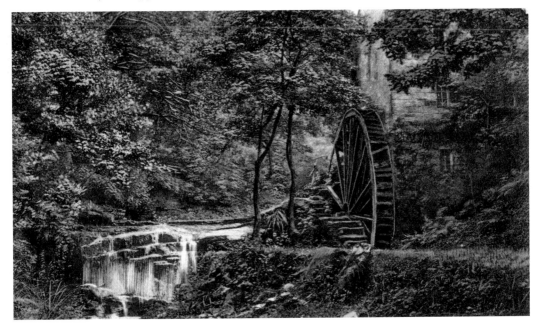

Rigg Mill, around 1925.

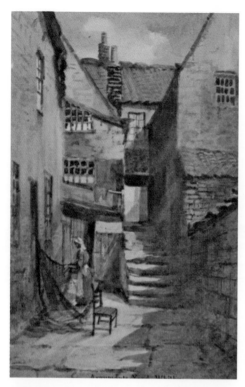

Two views above of Argument Yard a century apart. The view above shows the yard at the end of the eighteenth century, with a woman outside her cottage mending fishing nets. The view below is seen a century later and appears to be in a dilapidated condition and due for demolition.

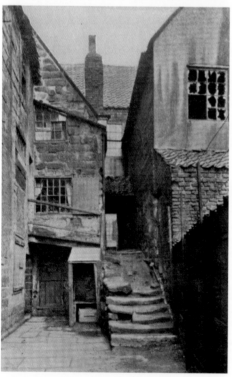

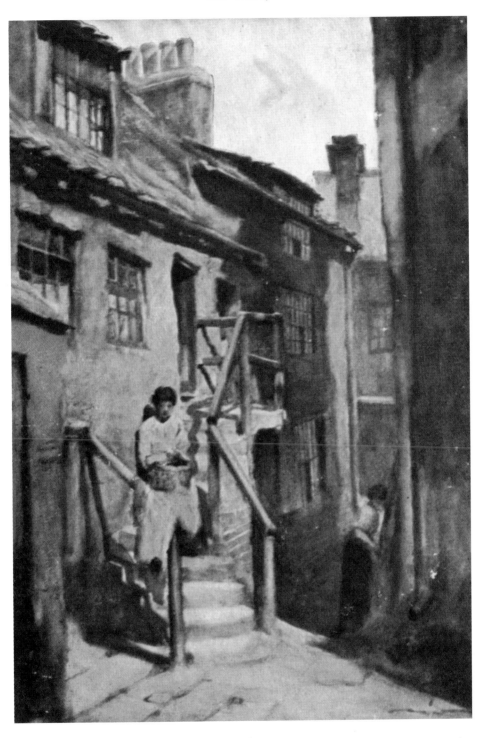

Cottages at Whitby in the nineteenth century, with women working at the domestic tasks needed in those days.

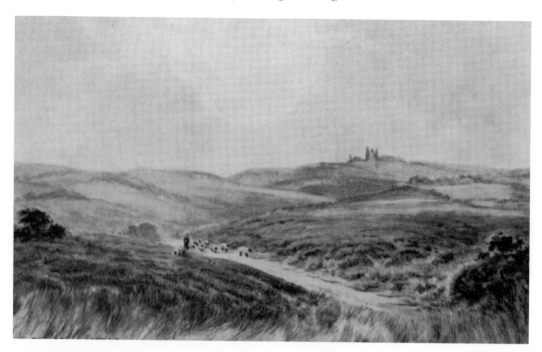

The moors at Whitby with the abbey in the distance.

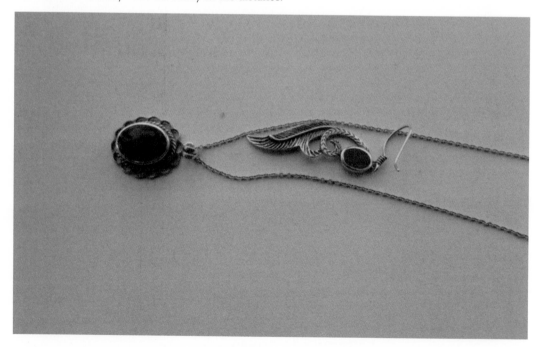

This view gives an example of jewellery made from Whitby's famous jet. Whitby jet has long been claimed to leave magical properties and is a protection from evil. When cut and polished, Whitby jet gives a deep black shine and there are several manufacturers and retailers in the town.

WHITBY RAILWAY

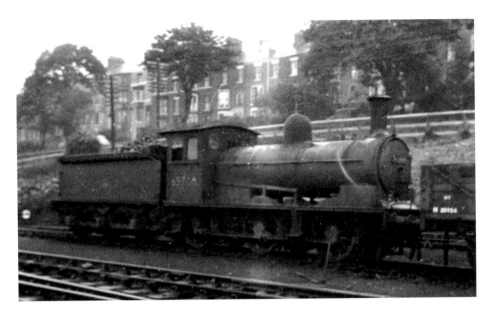

Ex NER/LNER Class J25 0-6-0 No. 65700 at Whitby locomotive shed on 22 August 1954 is featured. These engines worked local freight traffic from Whitby as well as some local passenger trains. The shed here closed on 6 April 1959 and was subsequently used as a fish packing warehouse.

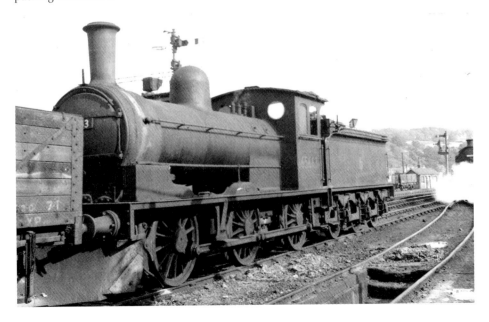

Pictured here is another J25 0-6-0 is seen outside Whitby locomotive shed on 15 July 1956. Unusually for the time of year, it is fitted with a snowplough at the front. The shed here was probably built by the Y&NMR in 1847 and further extensions were added over the years.

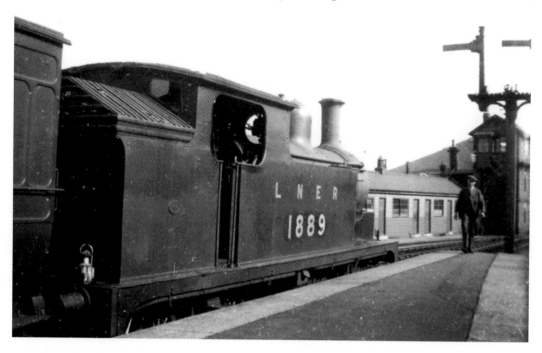

Two views of Whitby Town station in the 1930s. The upper view shows LNER Class G5 0-4-4T No. 1889 about to depart with a local train for Malton using the line to Grosmont, travelling along what is now the North Yorkshire Moors Railway to Pickering (purchased by the Y&NMR in 1845) and then to Malton via the line to Rillington. The final leg is along the main Scarborough to York line to Malton. Apart from the Esk Valley line from Whitby to Middlesbrough, all the other lines closed in the 1960s. Below is Sentinel railcar 'Britannia' with coach attached at Whitby station in June 1934. These railcars were introduced by the LNER as a way of reducing costs on local services, but they only had limited success and were all gone by the mid-1940s.

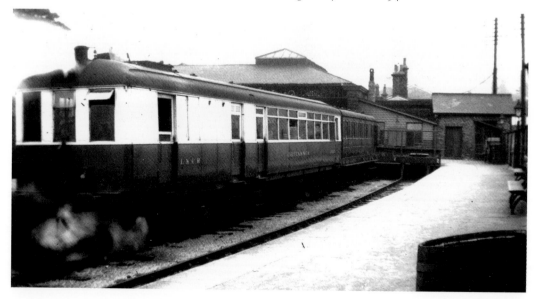

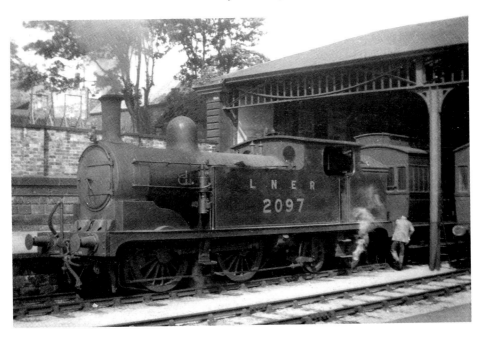

LNER G5 Class 0-4-4T No. 2097 at the head of a local train in Whitby station in June 1934. The overall roof and main building were designed by Y&NMR Architect George Andrews and were constructed after the line to Pickering had come under the control of the North Eastern Railway.

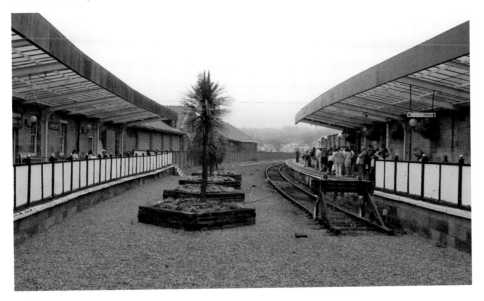

Seen above in 2005, the overall roof has gone and only a single track remains, which serves the infrequent service to Middlesbrough. Indeed, the N&YMR operates occasional steam trains to Whitby from Pickering which utilises the line a little more. However, the station does look well cared for in this modern view.

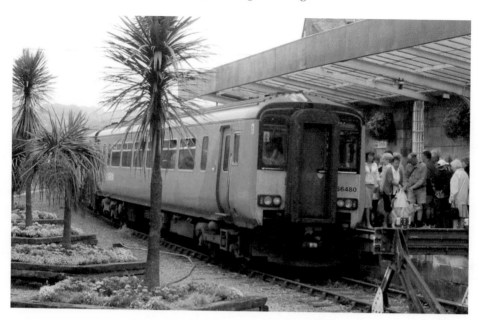

The modern Whitby station in 2005 with a local 'Sprinter' train having just pulled in. The platform appears to be busy with holidaymakers enjoying what the town has to offer and the attractive setting of the station. The North Yorkshire Moors Railway is planning to lay another track and platform at Whitby station and run steam trains on a regular basis between here and its terminus at Pickering.

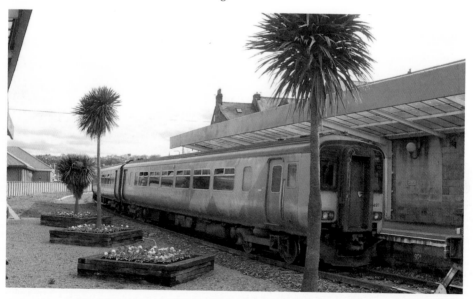

About to depart from Whitby station in 2005 is the local 'Sprinter' service for Middlesbrough, running along the only railway line which serves the town, that of the Esk Valley. It is such a shame that a line could not have been retained from Scarborough, as it now leaves Whitby isolated from the main rail network.

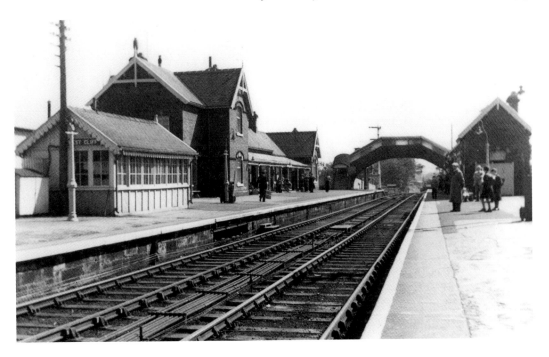

Whitby West Cliff station in the 1950s. This was the station that served the Scarborough to Loftus line and a shuttle was operated between here and Whitby Town, this station now being the more important, Whitby Town only serving local traffic from Pickering and Malton. The upper view shows West Cliff station on 1 September 1956, while the lower view shows two ex-LNER Class A8 4-6-2s crossing at West Cliff in the 1950s. No. 69865 is at the head of a Scarborough bound train, running via Robin Hood's Bay.

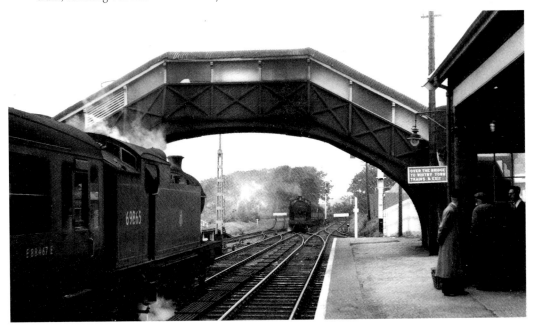

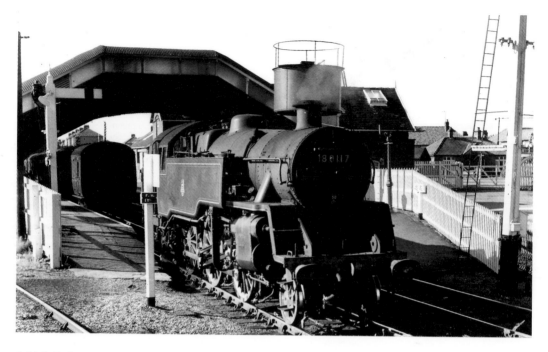

British Railways Standard Class 4 tank locomotive, based at Whitby, setting back onto its train at West Cliff station in the late 1950s. Although summer traffic could be heavy, the winter timetable in the years after the Second World War showed poor use of the railway from West Cliff to Loftus. The iron viaducts on that line also required heavy maintenance due to the salt air locally. Thus, in 1958, it was decided to close that section of the line and the last train ran on 3 May 1958.

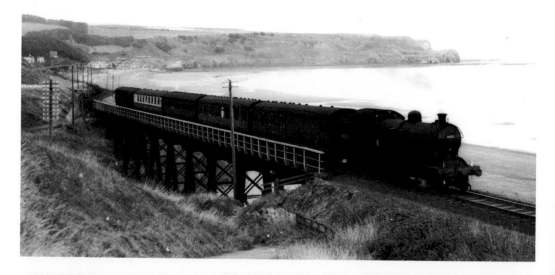

Pictured here is an iron viaduct at Newholme Beck, with an A8 locomotive at the head of a train for Scarborough.

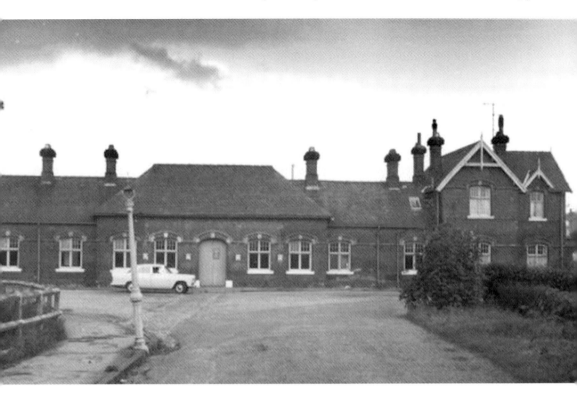

Although the line to Loftus had closed, the line to Scarborough remained open, making West Cliff a terminus for a while, but it too closed on 10 May 1961 and the Scarborough line itself closed on 6 March 1965. The station buildings have remained since closure and were used by Yorkshire Water for a while. In 2001, the whole site was purchased for redevelopment as modern housing and the result can be seen in these two views. The lower view in particular shows the old station as housing looking up Station Avenue.

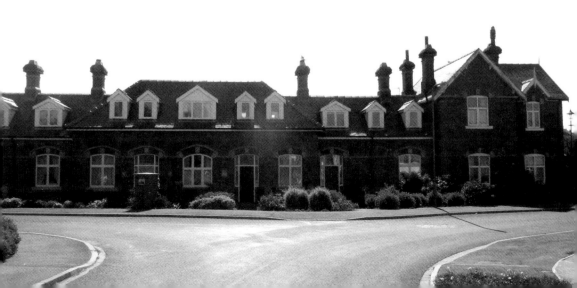